SAN RAMON

P9-CKB-666

Donated by

SAN RAMON LIBRARY FOUNDATION

100 Montgomery • San Ramon, California 94583

Leonardo

WITHDRAWN

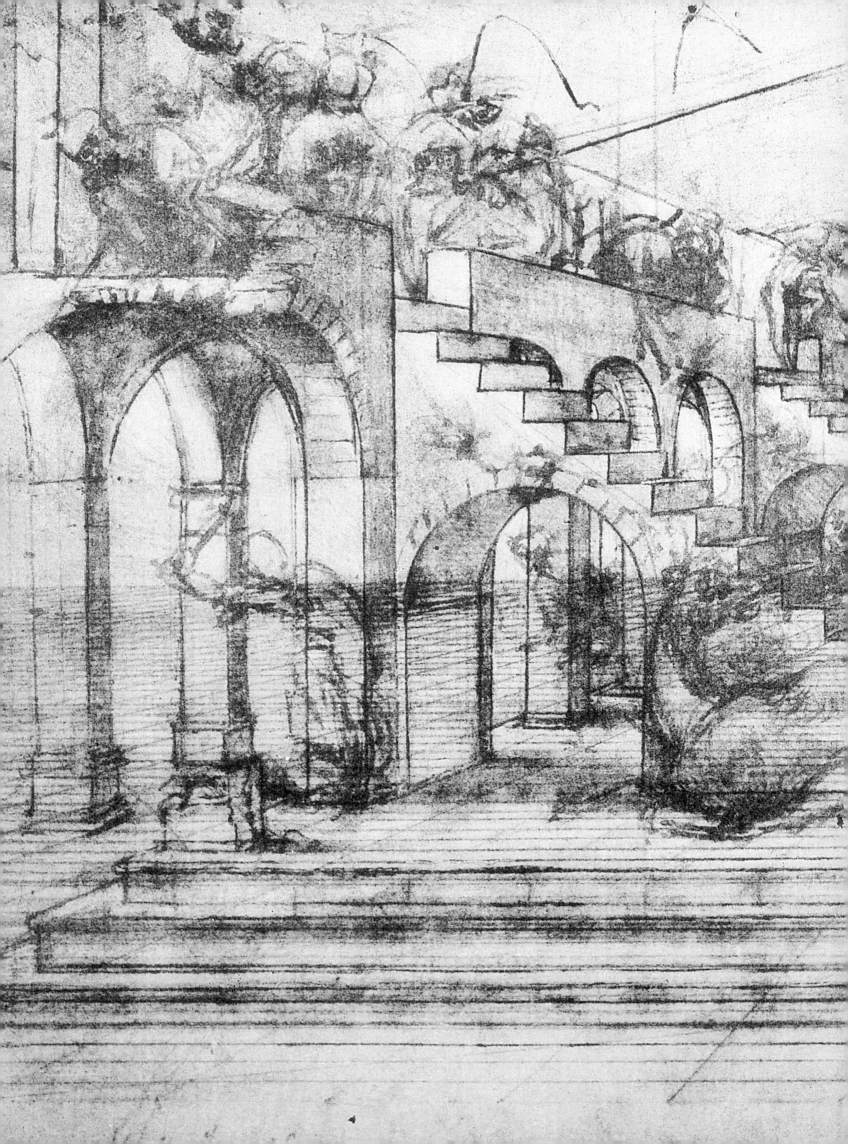

Leonardo

Trewin Copplestone

GRAMERCY

3 1901 02402 4186

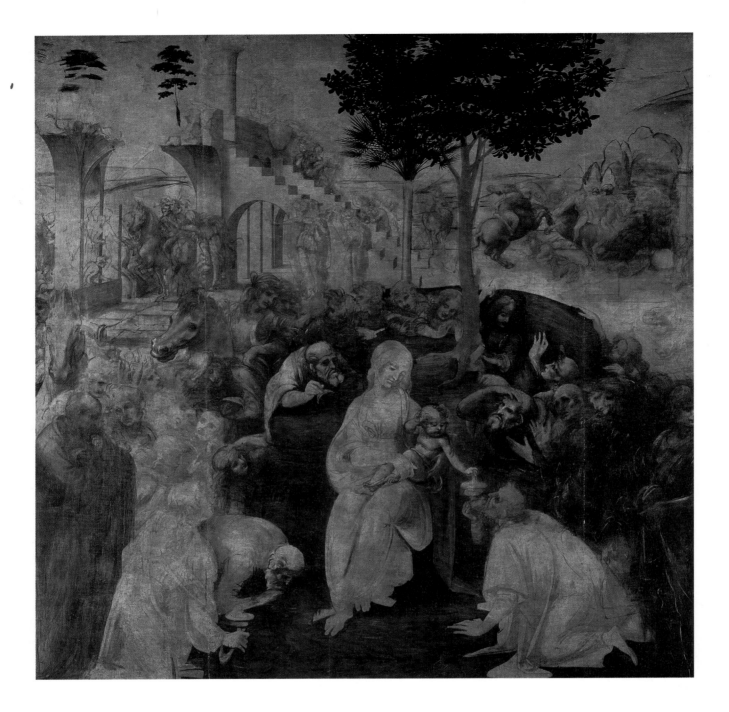

Copyright © 1998 Regency House Publishing Limited

No part of this book may be reproduced or transmitted in any form or by any means
electronic or mechanical including photocopying, recording, or by any information storage
and retrieval system, without permission in writing from the publisher.

This 1998 edition is published by Gramercy Books, a division of Random House Value
Publishing, Inc., 201 East 50th Street, New York, NY 10022
Gramercy Books and colophon are trademarks of Random House Value Publishing, Inc.

Random House New York • Toronto •London • Sydney • Auckland
http: / / www.randomhouse.com/

Printed in Italy

ISBN 0-517-16062-5

10 987654321

List of Plates

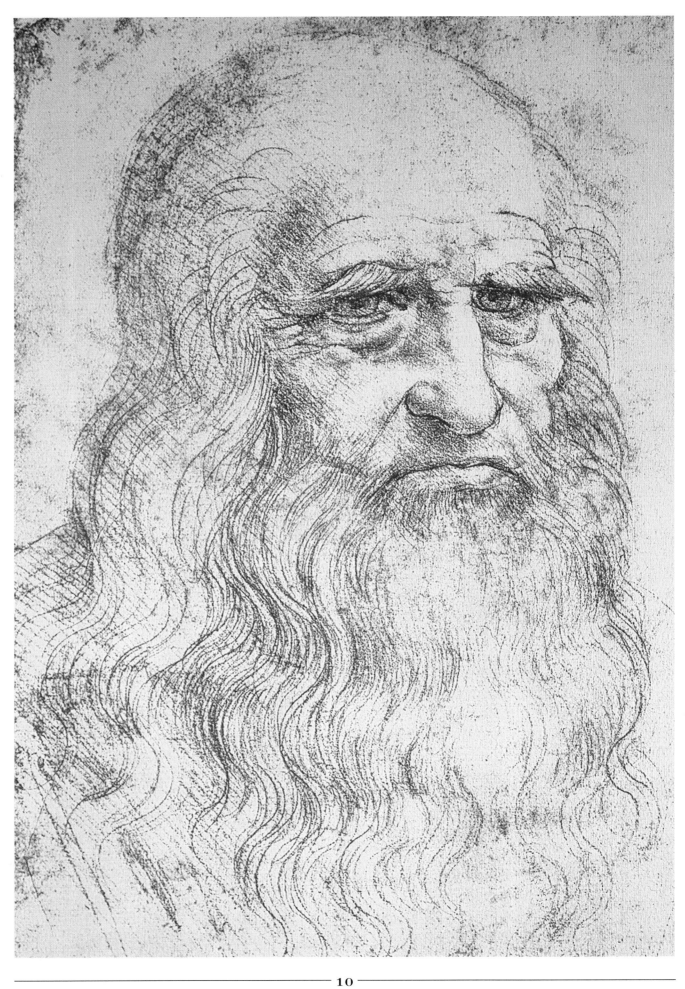

PLATE 1

Self-Portrait (c. 1512–15)

Sanguine (red chalk on paper), 13$\frac{1}{8}$ x 8$\frac{3}{8}$ inches
(33.3 x 21.3cm)

Leonardo's presentation of himself as an ancient sage, with long beard and severe demeanor has been analysed by a number of writers since he drew the portrait in the last years of his life. One comment from the 16th century is that Leonardo wore his hair and his beard so long and his eyebrows were so bushy that he

appeared the very personification of noble wisdom. Is this how Leonardo actually perceived himself? Views of those who knew him varied greatly, but there was general agreement that he was a procrastinator who rarely finished anything, with which view any writer on his career is bound to agree. Pope Leo X summed up his view of Leonardo thus: 'Alas, this man will do nothing; he starts by thinking of the end of the work before its beginning.' This assessment of a man whose life achievement seems to us unparalleled is a surprising reflection on Renaissance values.

One of the more interesting aspects of Renaissance civilization is that its genius did not spring from the privileged, educated and monied classes, but revealed itself in unlikely places, often developing from seemingly unpropitious beginnings. It is a measure of the freedom of thought then current that in the intellectual climate that the Renaissance fostered, there was no one route to achievement – nor one point of departure. These comments are made because they have a particular relevance to the subject of this book, Leonardo da Vinci, whose illegitimate birth to a peasant woman in an obscure fortified village in the foothills of Monte Albano could not have presaged that he would become perhaps the greatest universal genius in the history of mankind. It is always dangerous to deal in superlatives but if Leonardo cannot be said to fit this criterion, it is difficult to suggest another. An illustration of the difficulty in measuring genius may be found in the old, now abandoned, Intelligence Quotient test. One exercise attempted by its creators was to measure the intelligence of historical personages against that of great modern minds. Having completed a list and including such eminent figures as Isaac Newton, Einstein and others, they added as a footnote that Leonardo had not been included because he did not conform to any measurable criteria since the intelligence quotient figure they had arrived at was plainly impossible. The IQ system examined all forms of intelligence over a full range and the

wider the area of talent, the higher the IQ – hence the problem of Leonardo and the wide claims made for his pre-eminence.

This simple anecdote does offer, however, an indication of the problems that any analyst of his life and work will encounter. It is to diminish Leonardo not to examine the whole of his work; but can a writer on art evaluate his work on natural philosophy or a writer on music assess his inventions? Would it not in any event be a form of intellectual arrogance to attempt to do so? The easier solution is to compartmentalize Leonardo and deal only with that part of which a writer has a special knowledge. For the enquiring reader this is patently unsatisfactory since Leonardo was the sum of all his talents and if contemporary reports are true, a mightily attractive and amiable personality besides.

So how to proceed in a book intended to be about art, and one which is to be written by a person whose background could broadly be described as in art history? To add to that he may claim interest in a number of other subjects, sufficient at least, it is to be hoped, to indicate without claiming originality something of the range of Leonardo's extraordinary qualities. We are now accustomed to identifying uniqueness as a particularly human characteristic; but Leonardo has a different kind of singularity. There is no one of equal rank, either contemporary or historical, and this makes full and valid

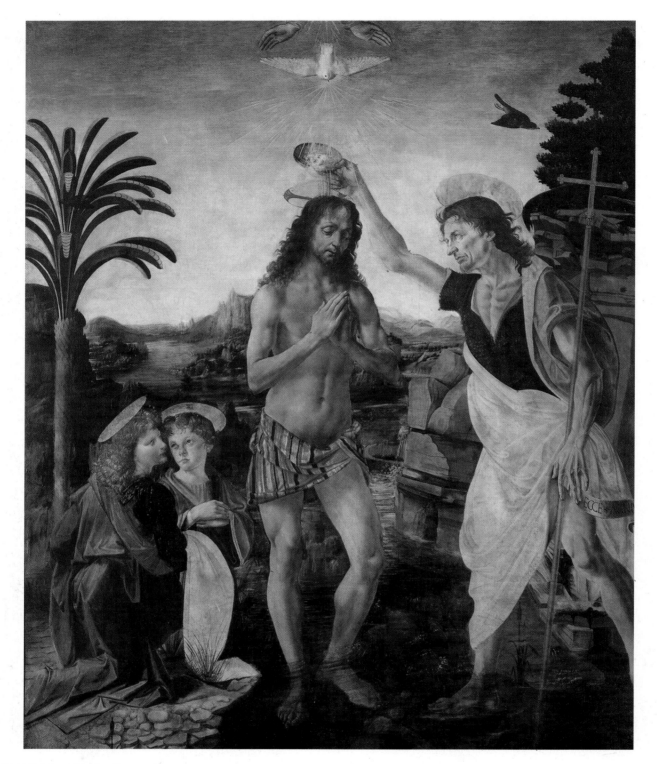

PLATES 2 and 3 detail opposite
Verrocchio: The Baptism of Christ (1472–75)
Tempera and oil on panel, 69²/₃ x 59¹/₂ inches
(177 x 151cm)

*Leonardo's contribution to this painting by Andrea del Verrocchio,
in whose studio he had served his apprenticeship, consists of the
figure of the kneeling angel on the left of the painting and possibly
some repainting of the landscape background. With hindsight, it is
possible to see some of Leonardo's qualities in this figure but it does*
*not stand out as demonstrably superior to the rest of the painting.
Leonardo's contribution was probably made in about 1472 after he
had been accepted by the Painters' Guild but while he was still
working in Verrocchio's studio in charge of painting commissions.
Leonardo's intervention in the painting which, it is believed,
included repainting or adding some details, was to substantiate in a
more effective form the triangular grouping of the figures, the foot of
the angel balancing the foot of the Baptist. It is probable too that he
made a major effect of space in the background with his repainting
of that area.*

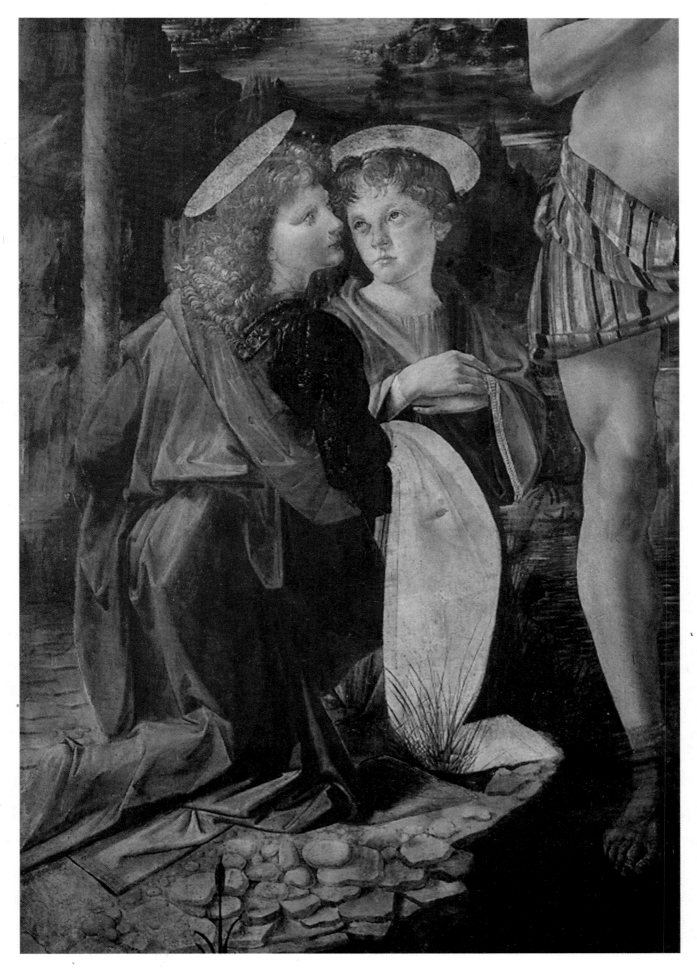

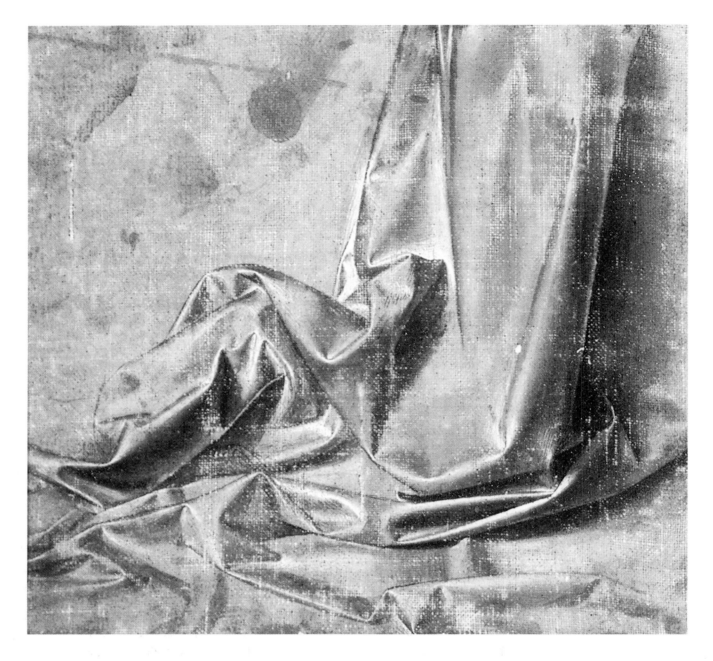

PLATE 4 above
Study of drapery (c. 1473)
Drawing with highlights (*à rehauts*), brush on linen,
heightened with white, 7¹/₂ x 9 inches (19 x 23cm)

*This kneeling figure viewed in profile from the right, provides a
careful study of the falling forms of a heavy textile material. It is
an example of the observational facility that was Leonardo's chief
quality. It is in such details that Leonardo has to be examined
and although the few paintings are of great importance in the
history of art it is such drawings as this that confirm his real
range. This is, of course, not including the essentially scientific,
exploratory or investigative drawings, or his drawings of designs
for architecture never built.*

PLATE 5 opposite left
Study for Virgin and Child with a Cat
Drawing, 9¹/₈ x 6⁷/₈ inches (23.2 x 17.5cm)

*When collected together, Leonardo's drawings of a single subject
reveal the development of his ideas and his basic intention more
clearly than might often be discovered from a finished work. They
are fresh, clear, brilliantly delineated statements. There are a
number of examples of pen drawings for this subject which was
intended to become a painting but which never materialized.*

PLATE 6 opposite right
Study for The Adoration of the Shepherds

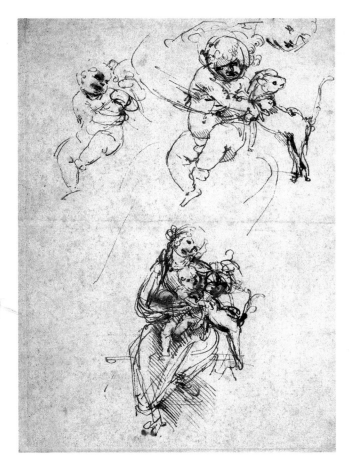

comparisons impossible. Nevertheless, he did produce two of the most celebrated paintings in Western art – the *Mona Lisa* (plates 50–53) known as La Gioconda, and the large mural of the *Last Supper* (plates 44–47) in the Church of Santa Maria delle Grazie in Milan.

The esteem in which these paintings are held demands some validation and to do this even superficially necessitates a restatement of the history of Western art and society because Leonardo's aim included a realignment of thought about the relationship of man to nature, of which he is a part. There is on the one hand his perception and appreciation of the visible aspects of nature – in art expressed through form – and on the other, what Leonardo describes as 'the intention of his soul'; what has been described as a 'functional equilibrium between substance and spirit'. Leonardo says elsewhere: 'A good painter has two subjects of primary importance; man and the state of his mind. The former is easy but the latter hard because it must be conveyed by the gestures and movements of various parts of the body.' It is surely no surprise to the reader that to identify these elements fully in literary terms is not possible since any form of visual art has its separate uniqueness of expression not translatable into another.

Even so, all rests upon only a few accepted paintings, a few more still disputed, extensive writings (including Leonardo's treatise on painting), and a mass of drawings and studies. This is of course to exclude the notebooks, the poems, the music, theatrical extravaganzas and court art, the inventions and scientific explorations and discoveries that make up the other parts of his life.

Perhaps the most useful, indeed necessary, beginning will be to try to place Leonardo in the context of his times. Some simple facts place him in history: Amerigo Vespucci, an explorer eponymously identifiable with America, was born in Florence only two years after Leonardo was born in nearby Vinci, and when Columbus is supposed to have discovered America Leonardo was 40 years old. Vasco da Gama discovered India in 1498 when King Henry VIII of England was seven years old and his contemporary in France, Francis I was four. The great Dutch writer Erasmus was born when Leonardo was about 12 and Gutenberg invented printing around the time of Leonardo's birth. Leonardo was 23 when Michelangelo was born and 31 when Raphael first saw the light of day. In most of Europe late medievalism continued while in Italy early signs of the Renaissance were already evident. At the time of Leonardo's birth, the Church of Rome was

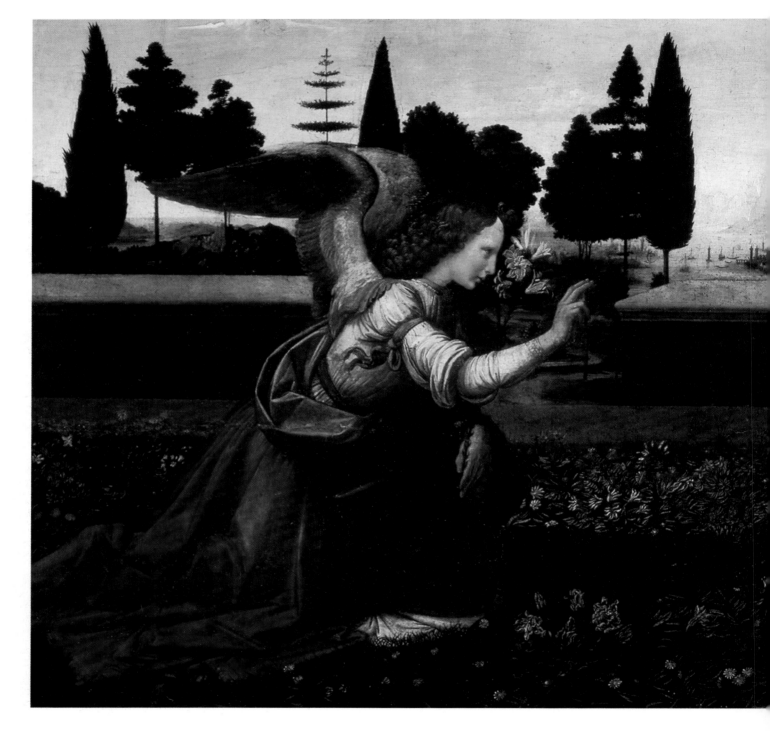

PLATE 7
The Annunciation (1472–75)
Oil on panel, 38½ x 85⅜ inches (98 x 217cm)

The unquestionable attribution of paintings in even the small number generally held to be by Leonardo is so rare that in most instances it is advisable to start with the caveat 'attributed' which usually means that academic debate still surrounds the matter of authenticity. This is particularly relevant when, as in the case of this painting, little is known of its provenance. Any student is therefore required to add an element of personal judgement to most

of the works discussed. In this Annunciation there are a number of points to consider. The painting only came to public view in 1867 when it was obtained by the Uffizi and shown as a Leonardo for the first time – not a good start. Before this, it had been owned by the monks of St. Bartholomew at Monte Oliveto and attributed to Domenico Ghirlandaio. This attribution is now discounted but the only element that most authorities accept as indisputably Leonardo is the background landscape. It is also known that it was in Verrocchio's studio and that, in consequence, was available to Leonardo. All that further is generally agreed is that the only other part that Leonardo may

have worked on is the left side and the angel and the disposition of the elements of the strong composition seem likely to have been his. What may certainly be said is that Leonardo was about 21 when the work was created.

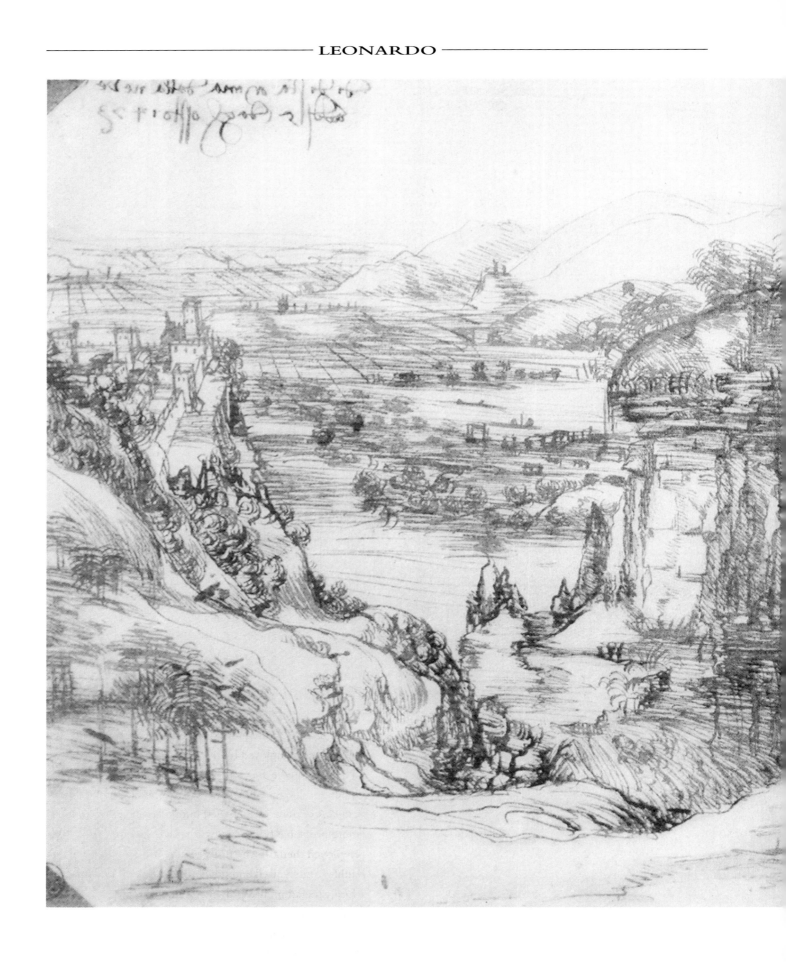

Leonardo

PLATE 8
Study of landscape (Val d'Arno) 1473
Pen and bistre (burnt wood ink), 7³/₄ x 11 inches
(19.6 x 28cm)

*Landscape studies, from small elements to wide vistas, recur
throughout Leonardo's notebooks and this broad pen drawing,
identified by some as the valley of the Arno, is more imaginative
than precisely accurate. Some of the details seem to be in
disjointed relationship suggesting that Leonardo's mind is directing
the construction of this drawing rather than accuracy of vision.*

the most important single influence in European life at a
time when a new intellectual impetus, inspired by classical
Greece and Rome, was motivating scholars throughout all
the countries of Europe.

Leonardo da Vinci is a figure central to the Italian
Renaissance, a contemporary of Michelangelo (1475-
1564) and Raphael (1483-1520) and with them represents
the High Renaissance, a stage in a long process which
began in the 14th century. Italy was not then a single
nation but an agglomerate of individual self-governing
entities with a number of different organizational
structures. In the 13th century, most of the cities were
self-governing republics but by the 15th century a pattern
of city-states, with power over larger or smaller areas
around them, had emerged. These were either in the form
of republics, usually under the dominance of single great
families, such as the Medici in Florence; or had become
dukedoms, not infrequently through conquest by armies of
mercenaries employed by the cities to fight for them in
the petty internecine wars which frequently broke out as a
result of self-aggrandisement or mercantile disputes. The
captains of these mercenaries, known as *condottieri*, found it
more profitable to subdue by force of arms the cities that
employed them. In the first generation they were brutal,
ruthless, uncivilized and powerful but, by the second or
third generation, had grown cultured, assuming dynastic
ambitions to create civilized courts which would enhance
their images. The history of Milan and the Visconti and
Sforza families who successively made themselves dukes of
Milan is an example of this process.

There were two notable exceptions to this pattern.

continued on page 31

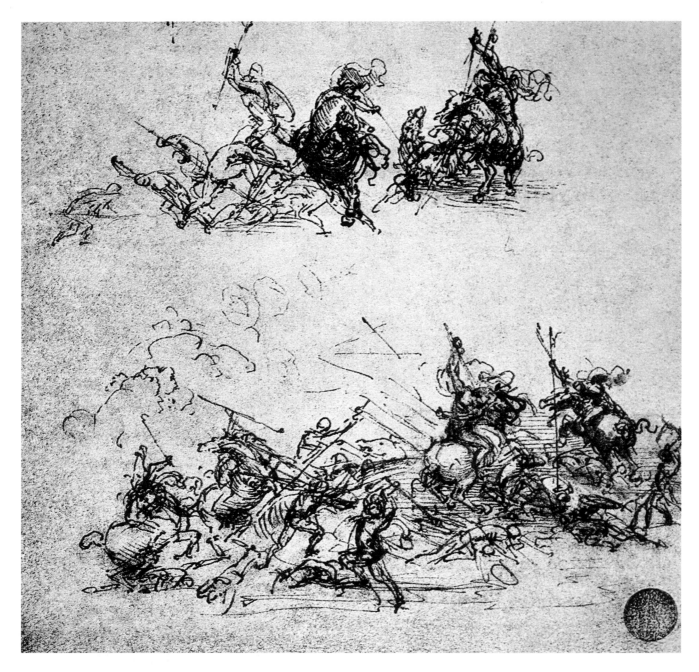

PLATE 9 above

Two studies for The Battle of Anghiari
(1503–05)

Pen and ink, 6¹/₂ x 6 inches (16.5 x 15.3cm)

The story of the decorations for the Hall of the Council in the Palazzo della Signoria in Florence provides a very interesting comparison between the great figures of the Renaissance, Michelangelo and Leonardo. They were each commissioned in 1503 to provide decorations from the history of Florence for the council chamber and by 1505 Leonardo had prepared his cartoons which were exhibited along with those of Michelangelo and appeared to those who saw them to provide a new statement of the power of Renaissance art and serving as an inspiration to the

new generation of young artists. Leonardo chose as his subject the battle of Anghiari, won by the Florentine Republic in 1440. Leonardo started work immediately after the exhibition to prepare for the painting of the wall in a new technical method, similar to that used for the disastrous Last Supper *(plates 44–47), and believed by him to be certain to work. To cut a long and testing story short, the method failed and the result was a more or less complete failure. Unfinished and ruined, it remained for about 50 years until Vasari covered it with new frescoes – at about the same time as he said that Leonardo's* Last Supper *was 'a muddle of blots'. All that remains are a number of sketches, of which this is one, and copies of details by others. It is typical and sad that what was certainly a much admired concept never came to fruition.*

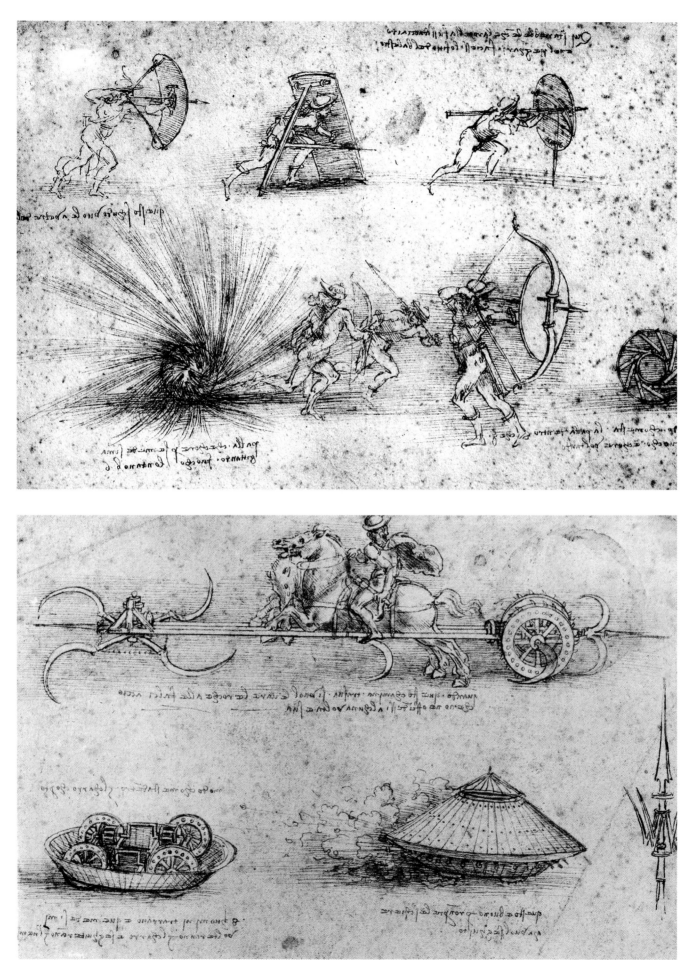

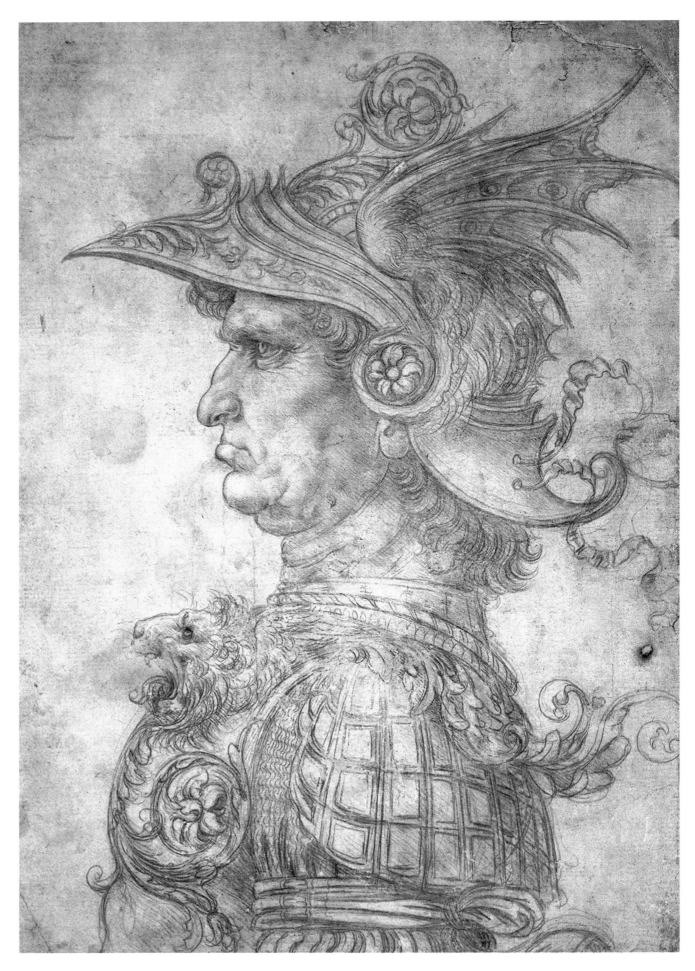

PLATES 10 and 11 page 21
War equipment
Pen drawings

Leonardo was professionally interested in war machines (one recalls his short period of employment with Cesare Borgia — see page 51) and was stimulated by any new problem. It is not surprising, therefore, to discover a unique inventiveness in these drawings. In the upper illustration he is concerned with personal defence when in violent close action, and appears to have thought of the effect of a rolling explosive device behind an attacker. Perhaps even more interestingly, in the lower drawing, he has attacked the problem of cavalry charges and developed this frightening multi-whirling scythed two-wheeled chariot designed to decimate the horses. The other object, seen externally and internally, is probably the world's first tank but not seen in action in a destructive form until 1915 during the First World War.

PLATE 12 opposite
Head of a warrior (c. 1480)
Drawing in silverpoint, 11¼ x 7⅞ inches
(28.5 x 20cm)

This fantasy is a collusion of swirling shapes as might be developed from what has come to be called a 'doodle' — the scribbling that may accompany a conversation on the telephone and which gradually elaborates itself into a completed drawing. It could be the sketch for a court masque or other entertainment.

PLATE 13 left
Study of a hanged man (1479)
Pen and ink, 7½ x 2⅞ inches (19.2 x 7.3cm)

The subject of this study in pen and ink is Baroncelli, the murderer of Giuliano de' Medici, younger brother of Lorenzo the Magnificent, who was killed in the Pazzi plot of 1478, one of the most notorious assassinations in an age when such occurrences were far from rare. The attempt to murder both Lorenzo and Giuliano while at prayer in the cathedral was organized by the Pazzi faction, who, since they failed to to kill Lorenzo, were hunted through Florence and killed, Baroncelli being hanged from the walls of the palace. Leonardo was at that time particularly interested in cadavers and made an accurate study on-the-spot from a subjective point of view.

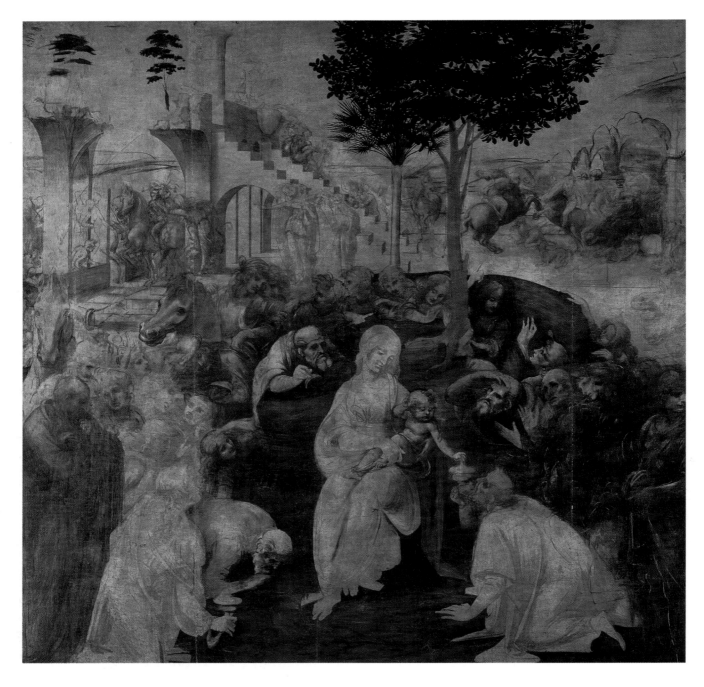

PLATES 14 and 15 detail opposite
The Adoration of the Magi (1481–82)
Underpainting on panel, 97 x 96 inches (246 x 243cm)

*When Leonardo left Florence for Milan in 1483 he had not
started the full painting and he never returned to complete it with
the addition of pigment. It is thus an incomplete underpainting,
little more than a drawing in monochrome in which the broad
areas of dark have been blocked in. The work has nevertheless
been subjected to considerable analysis and does represent*

Leonardo's ability to infuse new meanings into a familiar theme.

*In the centre, the main figures form a broad-based pyramid
while in an arc around them are the many followers, shepherds
and wingless angels. The two standing figures to the left and right
have been held to represent an embodiment of the Neo-Platonic
opposites – the active and the contemplative (the older man on the
left has been called 'the Philosopher'). It has been suggested that
Leonardo has symbolically expressed the control over human
actions and destiny by the cosmic forces.*

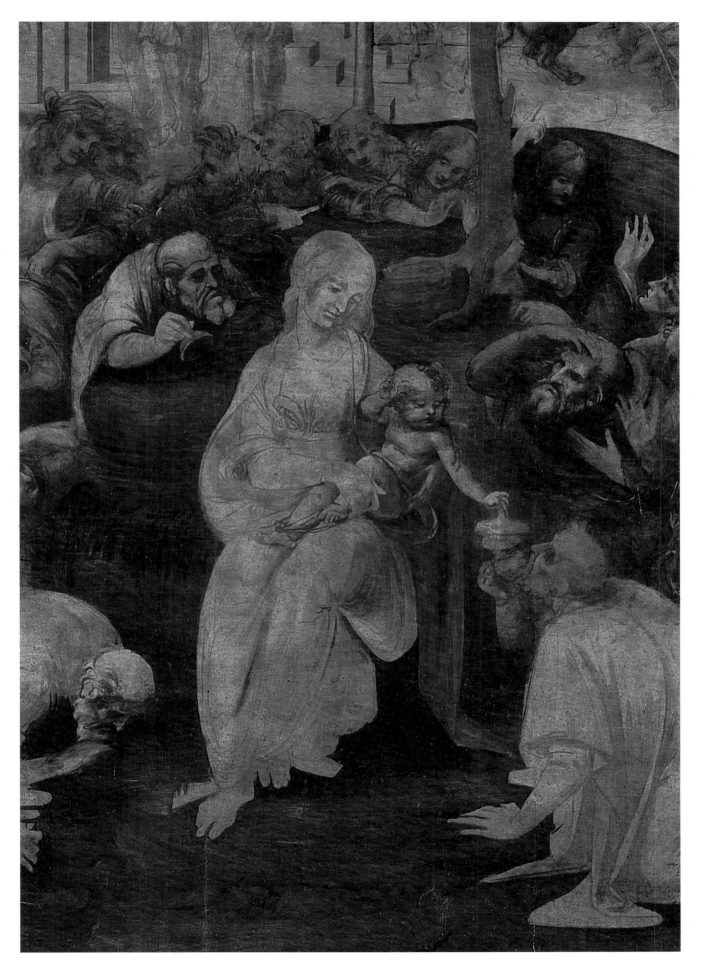

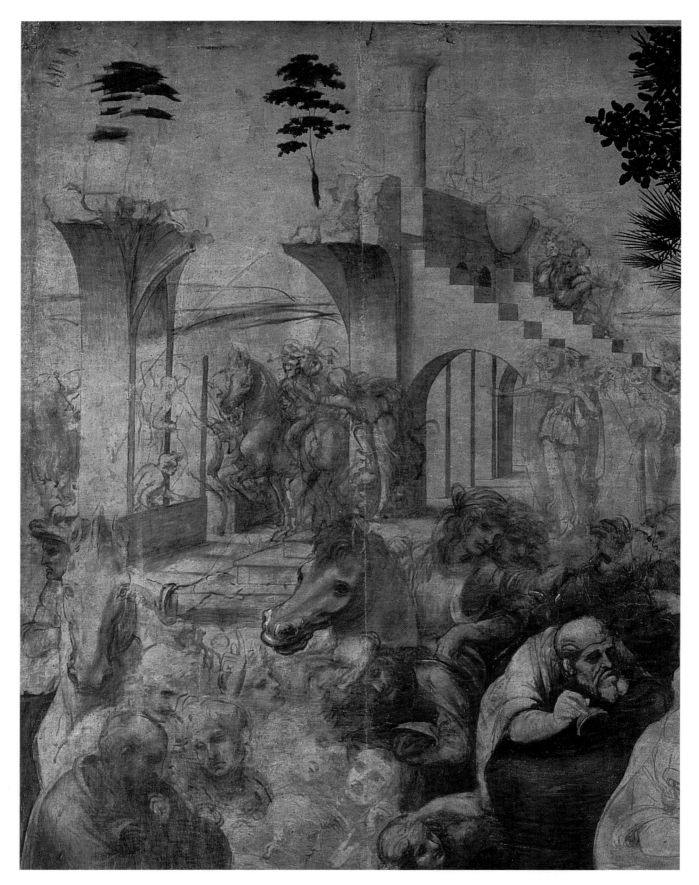

PLATE 16 detail
The Adoration of the Magi

PLATE 17

Preliminary sketch for The Adoration of the Magi (1481)

Pen and ink on paper, 11 x 8 inches (28.4 x 21.4cm)

The elements of important paintings were themselves constructed carefully and separately in preparatory drawings by most Renaissance artists and for the study of Leonardo they are

particularly significant since, as becomes evident throughout, Leonardo rarely entirely finished many of the works he started. The architectural structure of his painting The Adoration of the Magi *is carefully worked out in this drawing, much like a present-day stage set. The figures that are indicated are more for the positioning of the animals that might be included rather than the disposition of the central protagonists.*

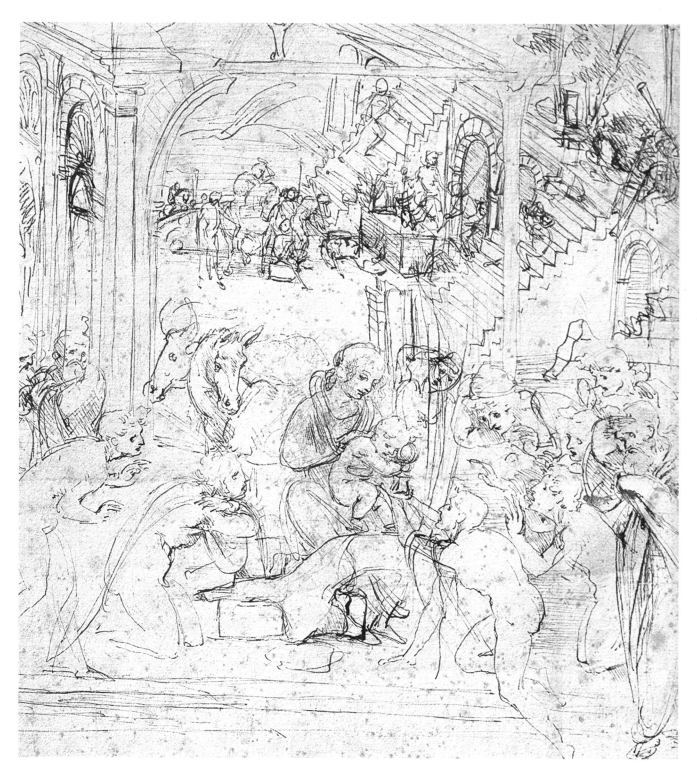

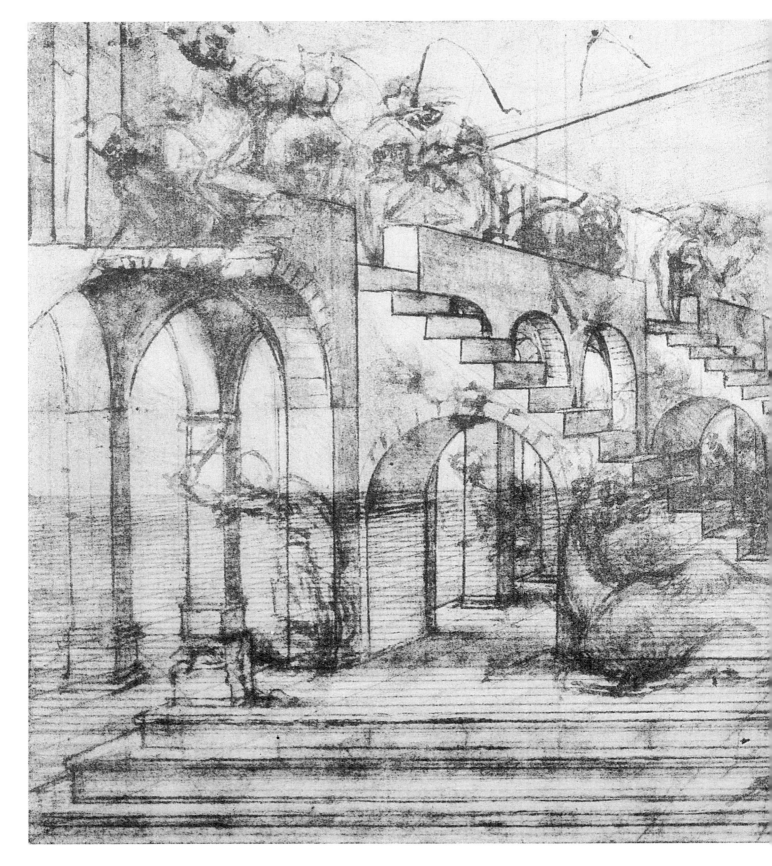

PLATE 18

Study of architecture with figures for The Adoration of the Magi (1481)

Silverpoint, pen and ink, $6^3/_8$ x $11^3/_8$ inches (16.3 x 29cm)

Leonardo's interest in spatial qualities of an architectural setting in his paintings is part of the practical concern with the whole practice of architecture for which he made many designs although none reached the construction stage. The subject of the Adoration of the Magi engaged his deep interest and this carefully constructed setting was part of that preparation.

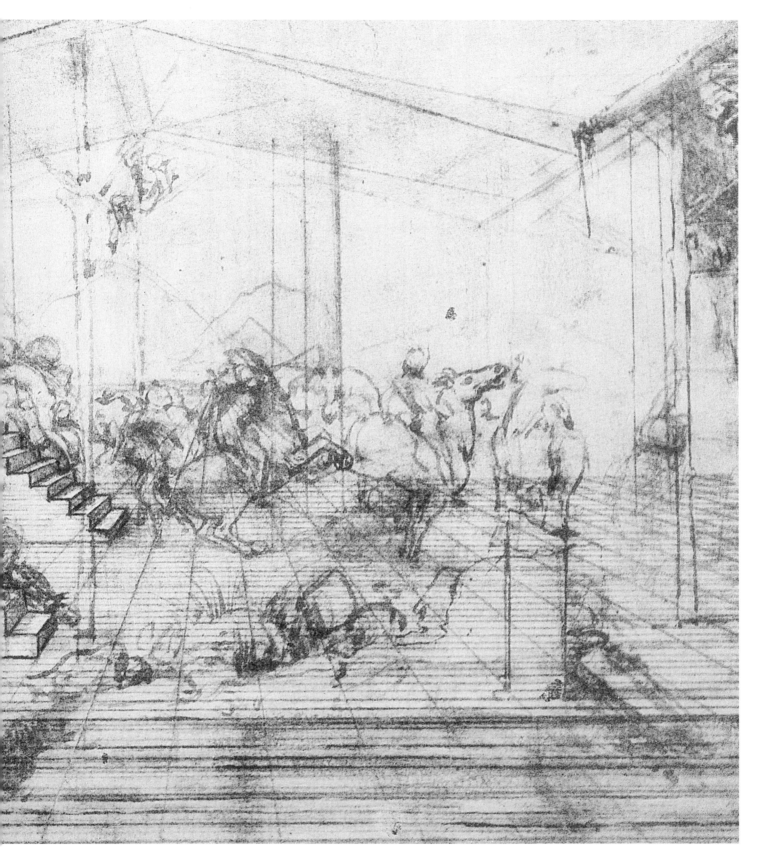

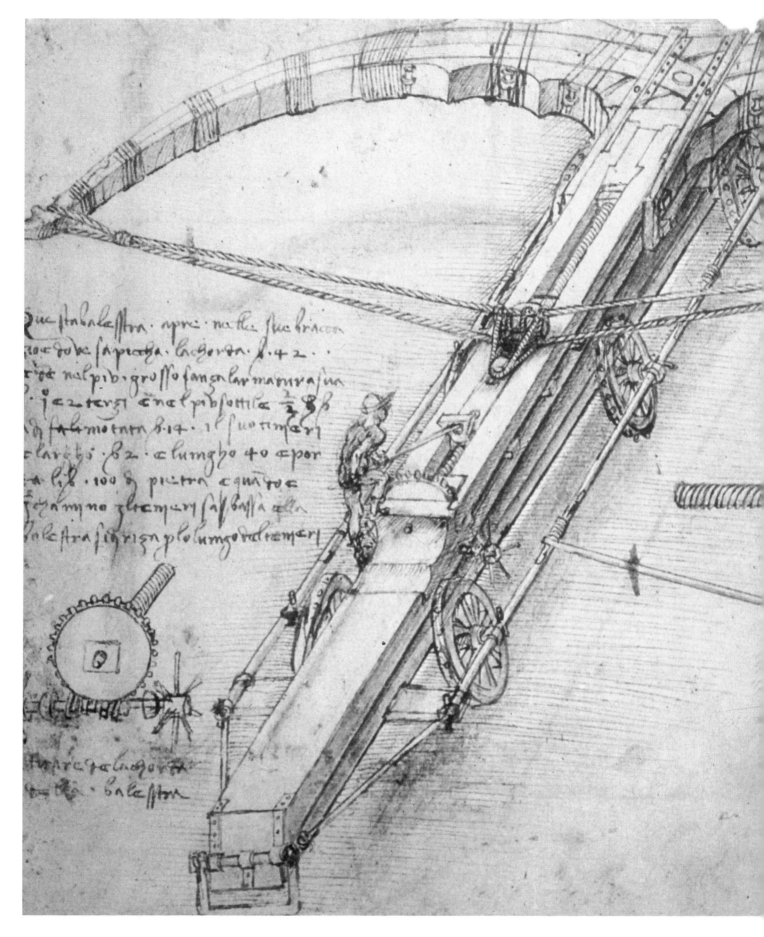

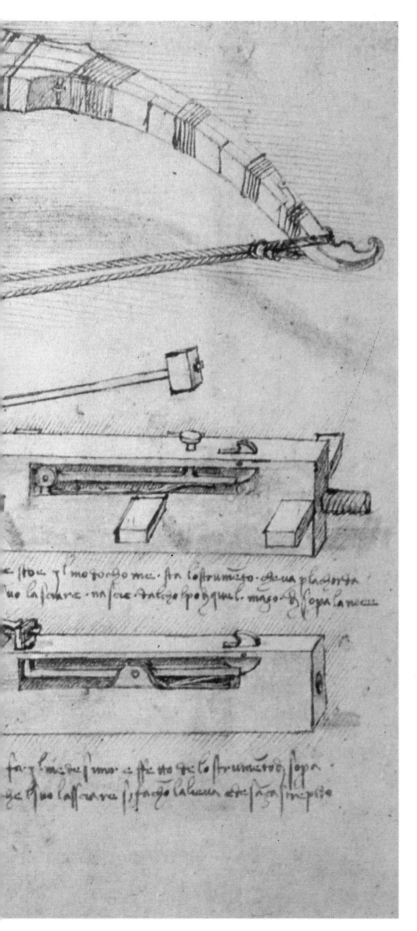

PLATE 19
Giant catapult

Silverpoint, pen and brown ink and white highlights on paper, $6^3/_8$ x $11^3/_8$ inches (16.3 x 29cm)

The intended scale of this terrifying object is indicated by the human figure and although, if constructed, it would probably have had a devastating effect, it is difficult to imagine a practical application even in Renaissance warfare for what would have been a lumbering behemoth.

continued from page 19

Firstly, Venice, which was an oligarchy ruled by members of ten families from among whose ranks the chief executive, known as the doge, was elected. The power of Venice in Europe was considerable. She was one of the great mercantile cities of Europe, with a great shipping tradition of trading with the East and importing goods for the rest of Europe. Rome, the second exception, the centre of Christendom, was dominated by the Church and in effect ruled by the pope, the most powerful individual in Italy, who wielded great power and influence throughout the whole of Christian Europe. A band of city-states stretching from Rome to the Adriatic coast were under the control of the popes and were known, not unexpectedly, as the papal states.

By the middle of the 15th century, at the time Leonardo was born, Italy had attained a special position unparalleled in the rest of Europe. Not only did it boast the acknowledged headquarters of Christianity, but it was also the repository of the greatest memorials of the most powerful civilization of the ancient world, the Roman Empire, including the temples and other great public buildings, in disrepair but still imposing, of Rome itself. To summarize a long and interesting story, Italy was the ground on which the contest between the Christian faith and the renewed fascination with classical Greece and Rome was fought. There was no clear victor in this contest but an intellectual revolution nevertheless took place which has conditioned the course of European, and later world history ever since. This did not occur through physical contest, although there was some of this, but mainly through the intellectual and emotional contest of

PLATE 20
Sketch for an aerial screw (ancestor of the helicopter)
Text and drawing

The fertility and inventiveness of Leonardo's inquisitive imagination was enormously stimulated by the idea of human flight and he made many drawings associated with the design of a flying-machine (see lower illustration and opposite) which led him to consider the movements of objects in the air. In this drawing he initiated a line of thought which has led to the present-day helicopter.

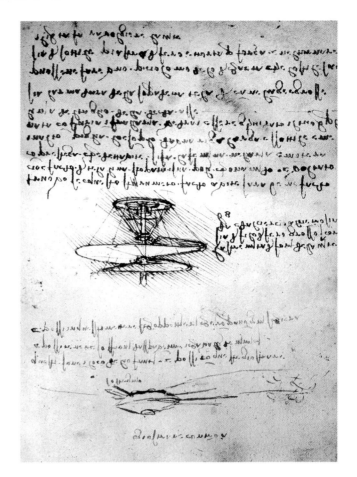

PLATES 21 and 22 right and opposite
Studies for flying-machines
Text and drawing

The notion that human beings might one day fly clearly fascinated Leonardo over many years. In a great number of sketches he attempted to contrive a flying-machine and many different methods of propulsion and elevation. His studies of birds in flight are part of that interest and their methods of flying were observed and the birds themselves dissected. Leonardo was aware of the lightness of a bird's body compared with its size. (See also plate 56.)

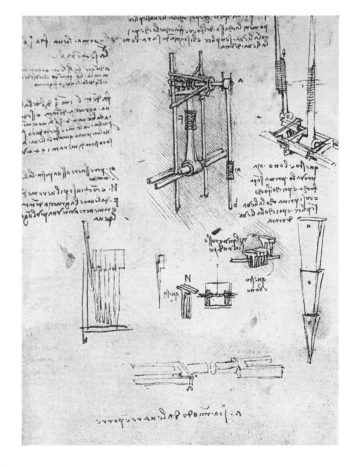

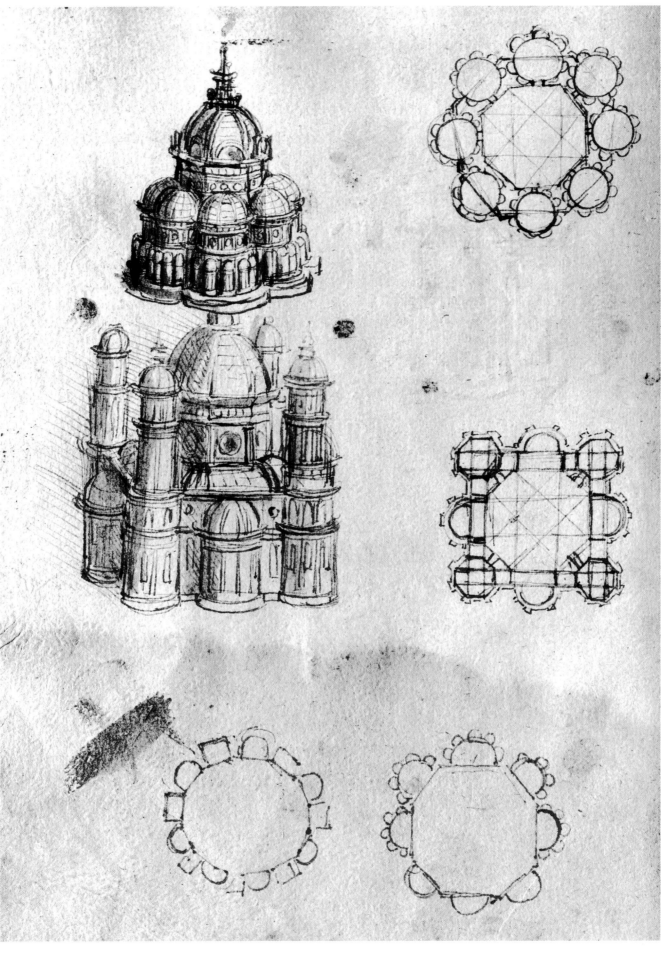

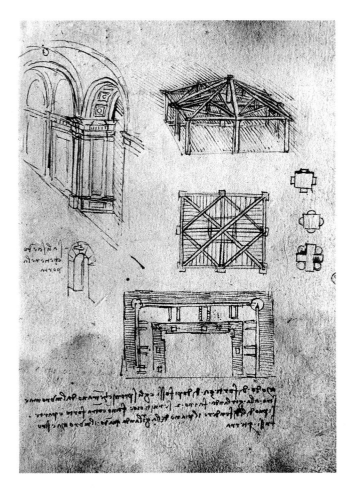

PLATE 23 opposite

Designs and plans for a church

Text and drawing

These drawings for a church plan based on a centralized Greek cross are reminiscent of Byzantine rather than classical Renaissance models, although the dome on the lower illustration suggests the Brunelleschian model of the duomo in Florence with added classical details. The related plans for the two buildings illustrated are to the right while the bottom two plans appear to be undeveloped notions.

PLATE 24 left

Building constructions

Text and drawing

Leonardo always carried his ideas towards a practical solution and this page from his notebooks contains notations of structural possibilities in wood and stone. It is interesting to note that the text is written from right to left – a facility that Leonardo used to inhibit curiosity. Of course 'mirror' writing only really requires a mirror.

mind and spirit. The clear course of Christianity, born fortuitously in the early Roman Empire and compromised in later Renaissance Italy by the qualities rediscovered in the philosophy and arts of Classicism, set the scene for the intellectual climate into which Leonardo was born.

Renaissance, which means rebirth, is the term used by later generations to identify that period of enquiry into the nature of classical art and thought which dominated from its early beginnings in the 13th century to the end of the 16th century. The philosophical stance, known as Humanism, permeated all the higher levels of intellectual life, first in Italy and subsequently in the whole of Europe. As its name suggests, it was concerned with the ethical rather than religious elements of humanity as transmitted through the Platonic and Neo-Platonic philosophies. The energetic enquiry thus stimulated covered all areas of man's endeavour and naturally turned to the manifestations of classical civilization for inspiration in the arts. And Italy, as noted, had many examples of Roman and some of Greek colonist architecture to study. The resulting burst of creative activity, mainly inspired by pre-Christian Classicism, constitutes the Renaissance.

Leonardo was born, as we have noted, when the

Renaissance had reached an advanced stage of development and had even 'infected' the Church to the degree that some of the most enthusiastic Humanists were senior churchmen, cardinals and even popes. In the houses of the rich and the courts of the dukes, centres of classical study were created which attracted and supported the philosophers and artists and there was much competition to acquire the services of the most revered among them. Artists were employed to create works of art, architects to design great buildings, and philosophers to debate complex ideas. The stage was set, in other words, for the arrival of a universal genius.

When he was 15, Leonardo was apprenticed to the Florentine painter Andrea del Verrocchio. As might have been expected he had a wide interest in many subjects in early youth, but his favourite pursuits were music, drawing and modelling. Verrocchio, although well known and admired, was not an artist of great originality. He was, however, a good technician and craftsman as a goldsmith, sculptor and painter as well as a highly regarded teacher. Leonardo was fortunate in receiving a good grounding in these crafts and remained with Verrocchio for about seven years. He was accepted into the Painters' Guild in 1472 at

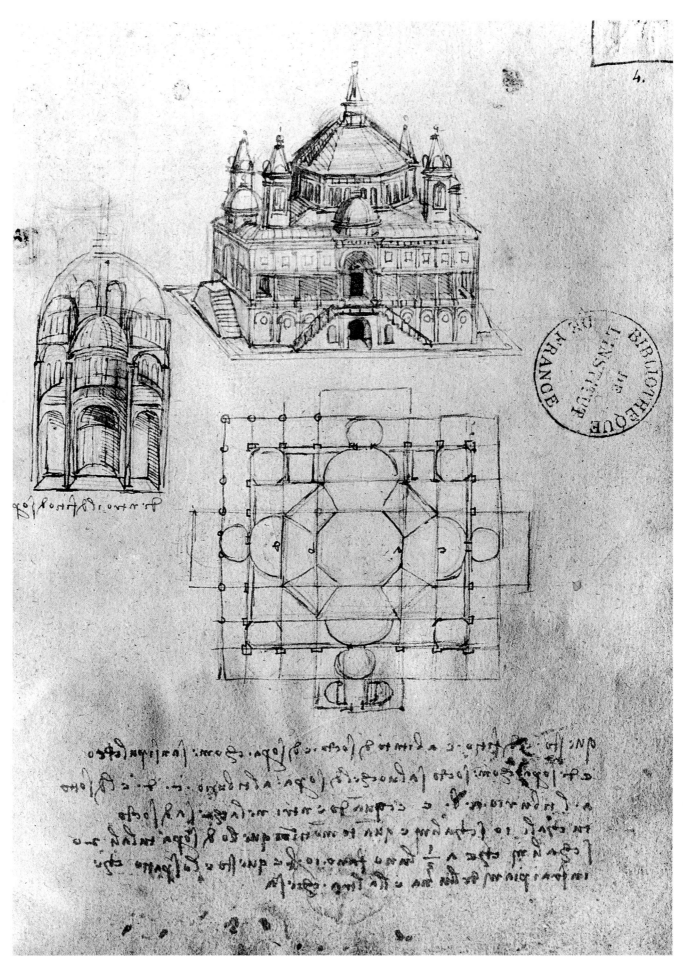

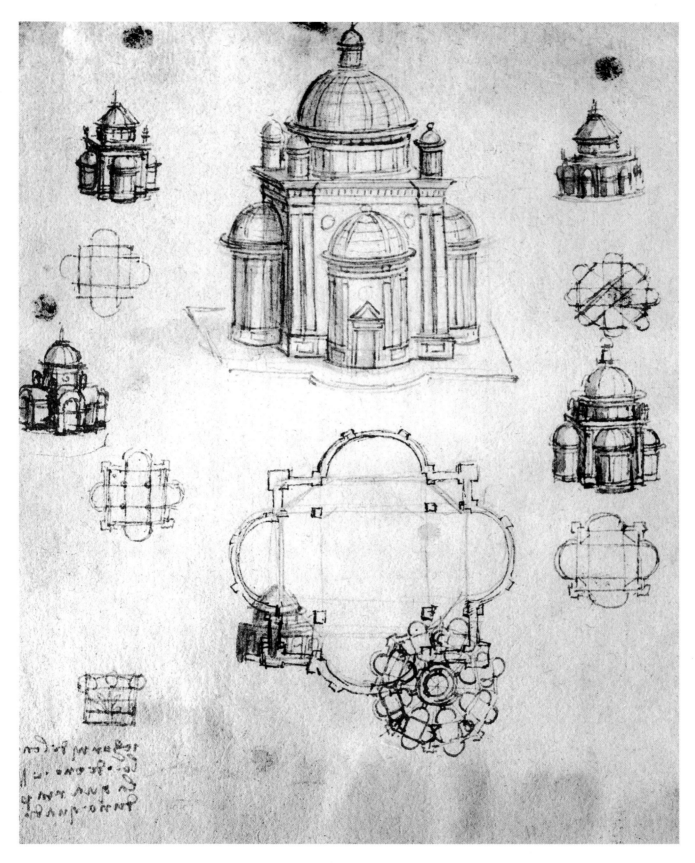

PLATE 25 opposite

Architectural drawing for church (such as that of San Sepulcro in Milan)

Pen and ink in sketchbook

PLATE 26 above

Plans and elevations of churches

Text and drawing

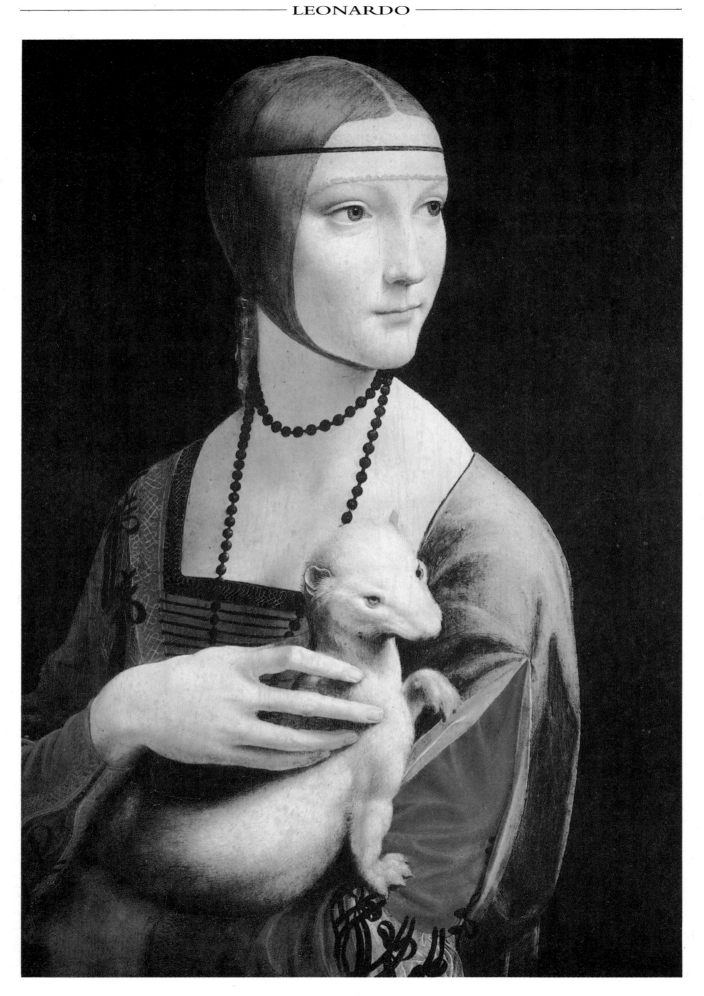

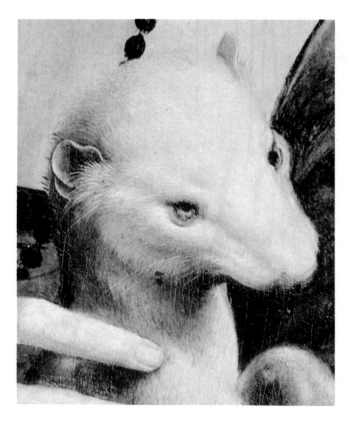

PLATES 27 (opposite) and 28 detail left

Lady with an Ermine (or Weasel) (1483–90)

Oil on wood, 21 x 15½ inches (53.4 x 39.3cm)

One of Leonardo's most enigmatic and charming portraits. The lady in question is Cecilia Gallerani who for 10 years charmed the court of Ludovico Sforza (Il Moro) in Milan with her great beauty and excellent wit. Traditionally, the ermine is a symbol of chastity.

the age of 20 and before he left acted as Verrocchio's assistant, working on a number of the master's paintings. It is now generally recognized, despite the doubts of some scholars, that Leonardo painted the figure of a kneeling angel on the left-hand side of Verrocchio's *Baptism of Christ* (plates 2 and 3). Any doubts arise from the fact that the painting, originally in tempera, has been subjected to so much later repainting in oil that it is difficult to be positive that any of the work is by the hand of Leonardo. It was nevertheless reported by Vasari, the great near-contemporary biographer of Renaissance artists, and this early evidence carries at least some weight. If it is indeed by Leonardo, it is the earliest example of his painting, executed when he was about 18 years old.

While still in Verrocchio's apprenticeship, Leonardo frequently visited the studio of the Pollaiuolo brothers, Antonio and Piero, whose great interest was in human anatomy – a Renaissance concern – and their paintings displayed figures in poses designed to reveal their knowledge of human figures in action. From them, Leonardo learned much on the subject of human anatomy which remained a principal interest for the remainder of his life. He was later concerned not only with the external form, but also with the expressive functioning of the mind through the body. Through the influence of the Pollaiuoli, Leonardo came to pursue the theory that significant muscular changes indicate a mental state and considered

the best way of understanding this was to study the actions of deaf mutes.

Lorenzo de' Medici, known as Lorenzo the Magificent because of his lavish life-style and the authority he wielded over the Republic of Florence, appears to have learned of Leonardo's great qualities in about 1478 after he had left Verrocchio's workshop and decided to take Leonardo under his patronage as an independent artist. Later, in about 1490, Lorenzo opened a school in the Medici gardens, of which Michelangelo became a member, and it became one of the most admired centres of Humanism in Italy.

Leonardo's first removal from the Florentine scene occurred in 1481 when he entered the service of Ludovico Sforza, known as Il Moro (the Moor) because of his unusually dark complexion. The rise of the Sforzas is an interesting but complicated example of the process of change in Italy from the republics of the 12th and 13th centuries to the dukedoms of the 15th and 16th centuries. It was an age of violence and perfidy, of cruelty and casual brutality, of unbridled and unprincipled ambition. Almost all the republics were destroyed through internecine warfare, the three most powerful being Florence, Venice and Milan; but early in the 14th century Milan came under the rule of the Visconti family. Giangaleazzo Visconti, a ruthless and scheming opportunist, had become

continued on page 47

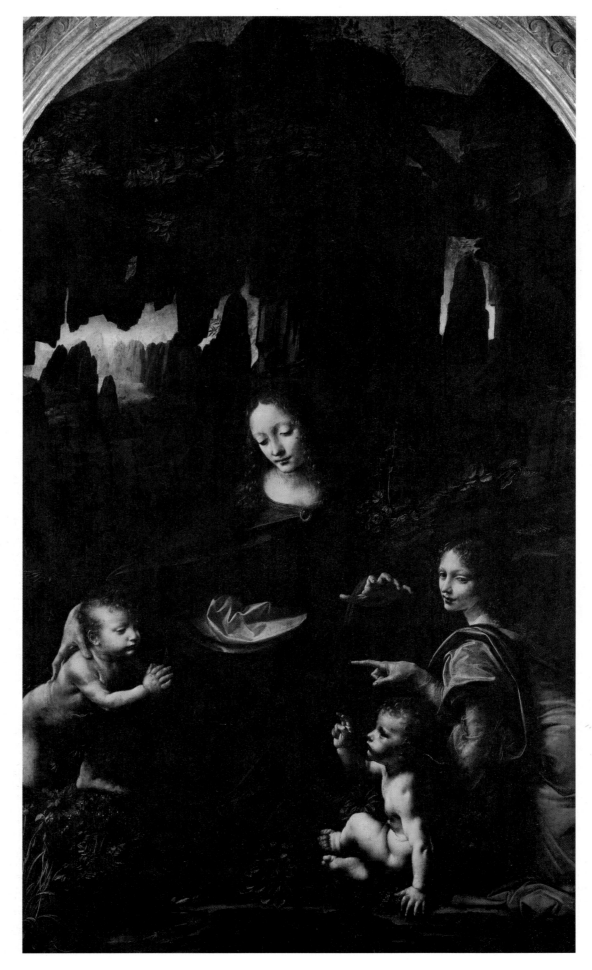

PLATES 29 opposite, 30 (detail below) and 31(a) and (b)
details overleaf

The Virgin of the Rocks (1483–86), Louvre

Oil on canvas (originally panel), $6\frac{1}{2}$ x 4ft (199 x 122cm)

There are two versions of this painting, the one in the Louvre, Paris (shown here) and another in the National Gallery, London.

The Louvre version is generally accepted as Leonardo's, but there is continuing doubt about the National Gallery version. The painting was the first work Leonardo undertook after leaving Florence for Milan where the Confraternity of the Immaculate Conception commissioned the work. It appears that the National Gallery version was the later and was the one accepted by the Confraternity, but this is by no means certain.

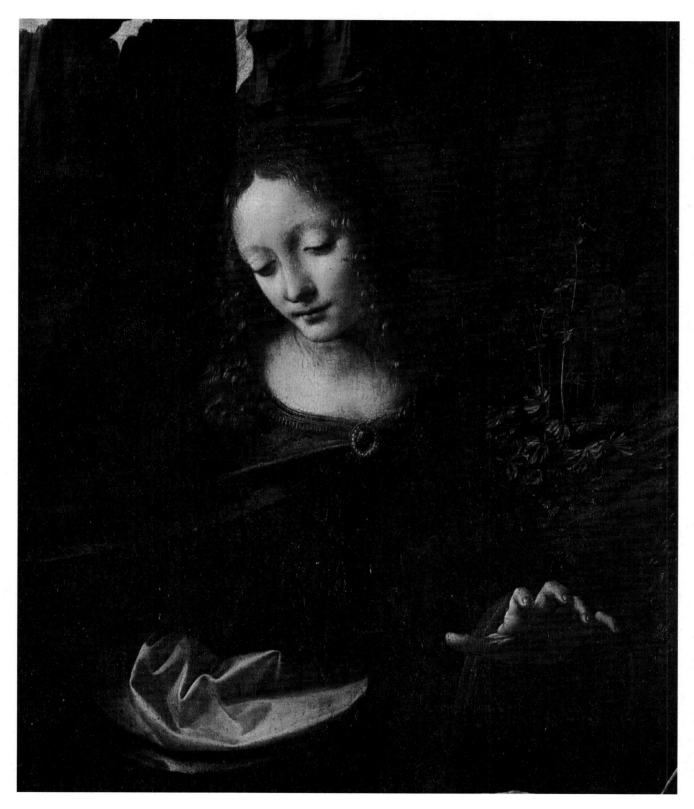

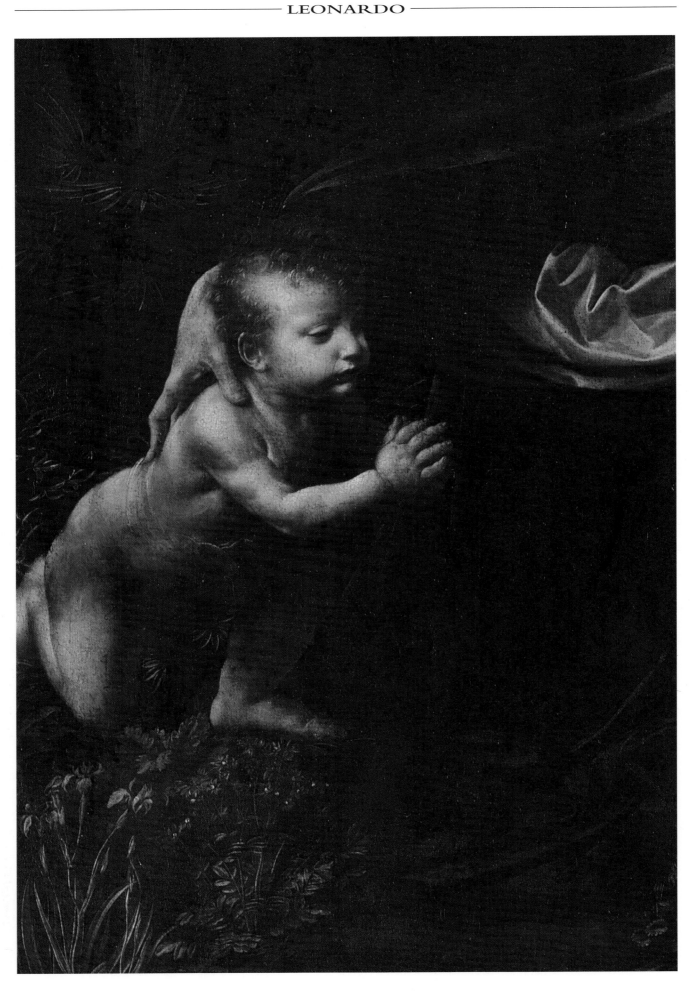

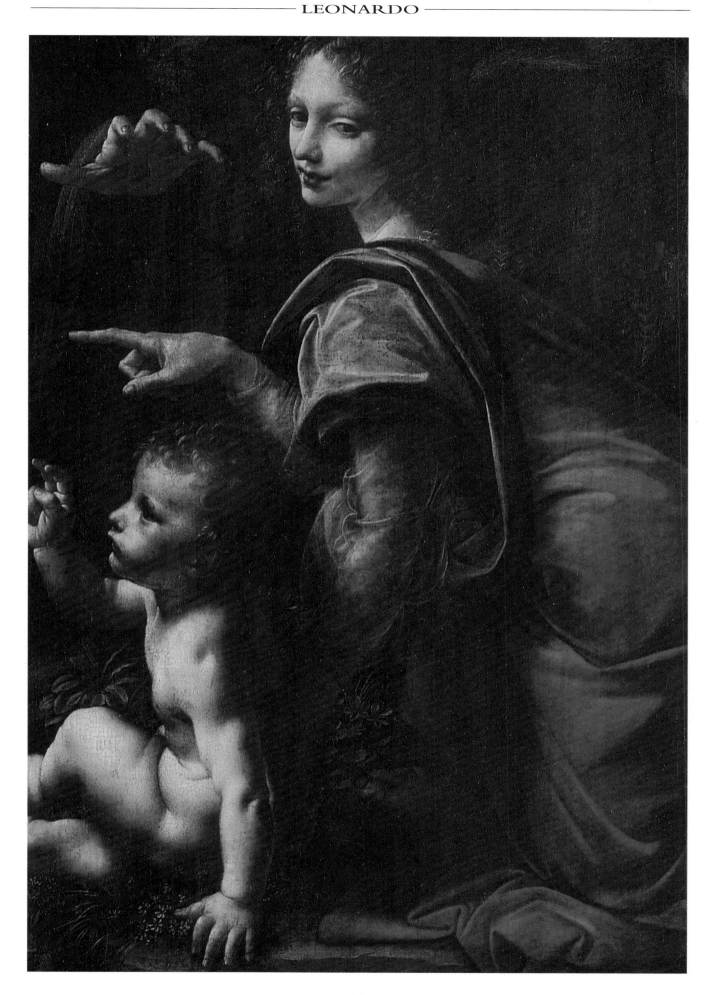

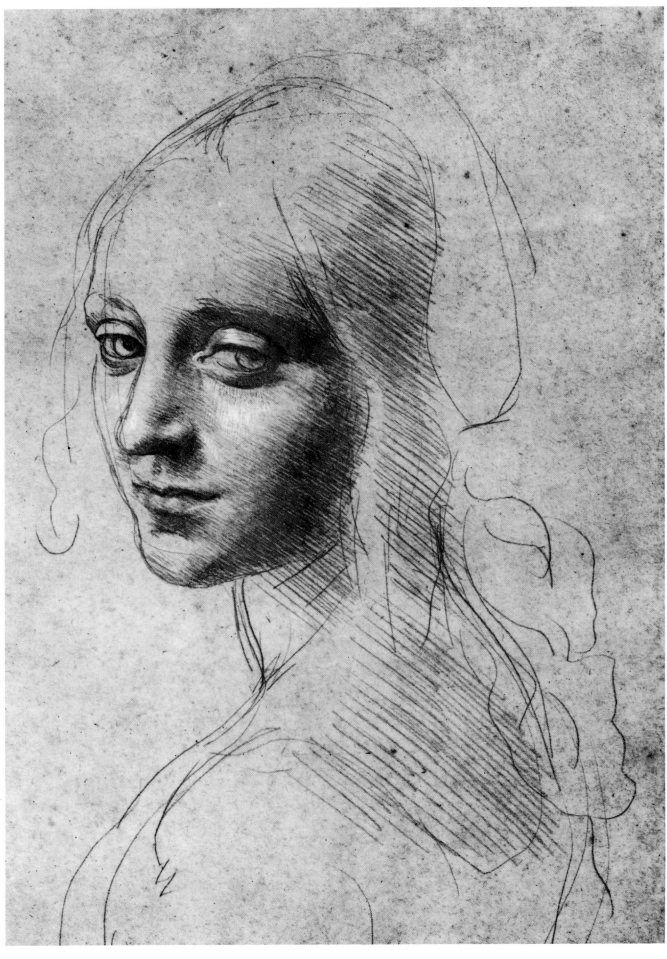

PLATE 32 opposite

Study for an angel's head for The Virgin of the Rocks (1452–1519) Louvre

Silverpoint touched with white on cream paper,

7$\frac{1}{8}$ x 6$\frac{1}{4}$ inches (18.1 x 15.9cm)

PLATE 33 below

Head of an old beardless man, turned to the left

Sanguine, 2$\frac{1}{2}$ x 2$\frac{1}{8}$ inches (6.3 x 5.4cm)

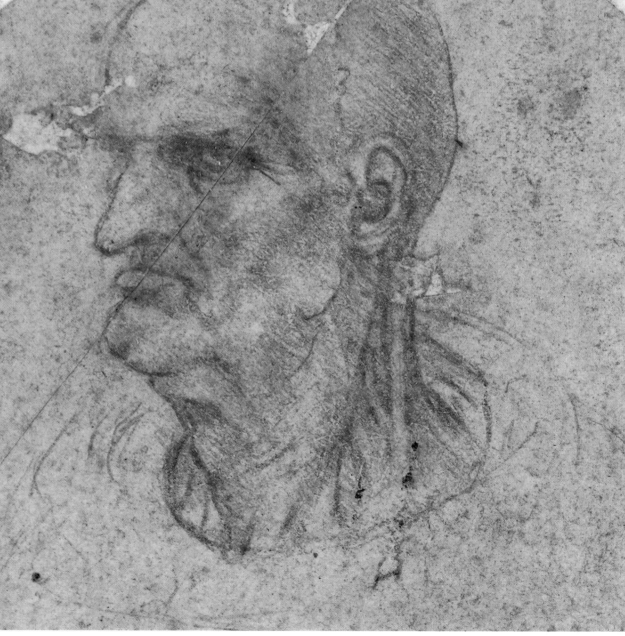

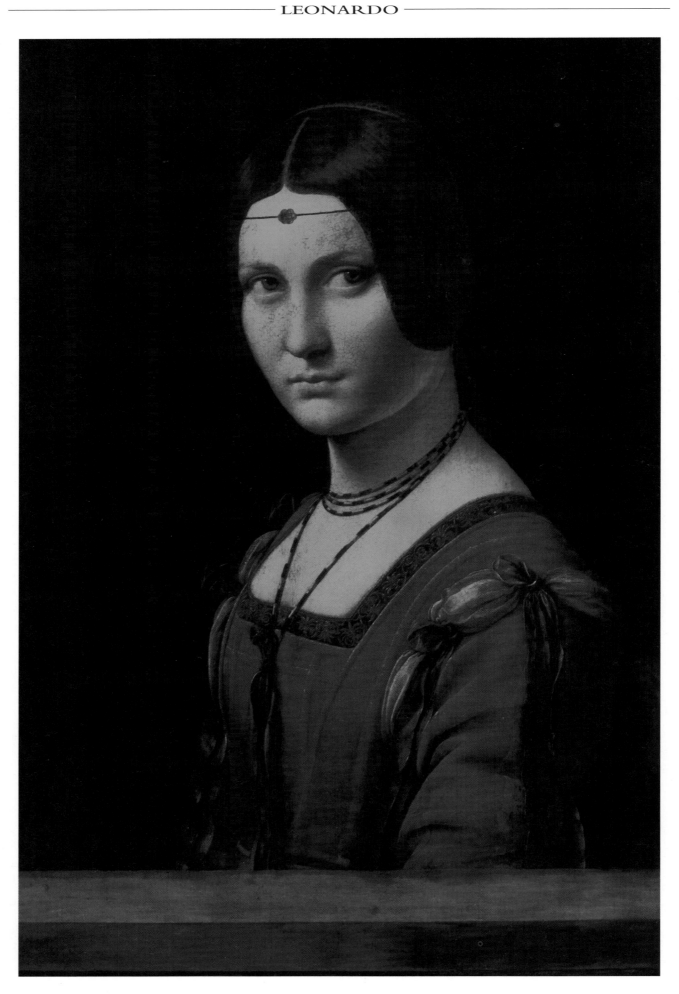

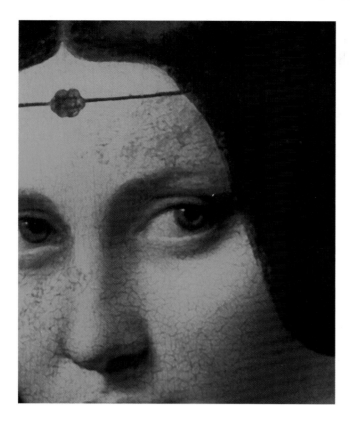

PLATES 34 (opposite) and 35 detail left
La Belle Ferronnière (c.1490)
Oil on wood panel, 24³/₄ x 17³/₄ inches (63 x 45cm)

At first sight this work would seem acceptably Leonardo's. It has some of the qualities of draughtsmanship and the forthright poise of the head and the subtle modelling of the nose could have come from Leonardo's brush. But the dress and style of painting of the accoutrements cast doubts. This is indeed one painting in which there is no unanimity. There are also some technical problems in the quality of the paint. It seems one of the examples of an attempt to extend the small oeuvre which constantly follows Leonardo's trail. It remains a possibility that it is his but it does not inspire the spirit as does the Mona Lisa *(plates 50–53) – or maybe it is partly his. The name* La Belle Ferronnière *refers to the band with its small jewel at the centre encircling the woman's head.*

continued from page 39

the richest and most powerful overlord in Italy by the time of his death at the beginning of the 15th century and was succeeded by his son Filippo Maria, the last Visconti Duke of Milan. He left no male heir, therefore leaving the question of succession in doubt, females being ineligible. However, two female relatives attempted to claim the throne and one of these was married to Francesco Sforza, another ruthless, ambitious and extremely talented *condottiere*.

On the death of Filippo, the Milanese declared a new republic; but through complicated, perfidious and effective military actions, Francesco Sforza, who had been employed by the republic to defend its borders, followed a course taken by many before him and subjugating the Milanese by force and intrigue, made himself Duke of Milan. A cunning man, he contrived to appear 'liberal, true and generous', but as one writer observed, 'It is not in the trade of captains of adventure that men can be formed to true honour.' But Francesco Sforza was a great and successful general and founded a short dynasty, being followed, on his death in 1466, by his son Ludovico. A mooted project to erect a monument to Francesco was revived by Ludovico and Leonardo was invited to Milan and given a commission to produce the work. Leonardo had himself petitioned Ludovico with an offer of his services in which, interestingly, he had described his

principal talents as those of a civil and military engineer.

Leonardo entered the service of Ludovico Sforza in 1481, at the age of 29, and remained there for nearly 20 years, departing in 1499 only on the expulsion of Ludovico by the French which signalled the imminent end of the Sforza dynasty. On his arrival, Leonardo produced a number of designs and models for the intended monumental equestrian bronze of Francesco Sforza, none of which survive. A number of sketches nevertheless show the nature of the designs (plate 54). One of these broke with traditional treatment of equestrian subjects as seen in the figure of the Roman Emperor, Marcus Aurelius, on the Capitol in Rome where, calm and dignified, he raises a hand in a gesture of peace. Leonardo's design depicts a rearing horse and a violent aggressive figure, much more in keeping with Francesco's character but extremely difficult to cast in bronze. It is one of many early signs of Leonardo's versatility that he also indicated in drawings how the figure might be constructed and the stress factors efficiently overcome.

Of the many works that Leonardo executed or left unfinished in Milan, few have survived. The most important of these are *The Virgin of the Rocks* (plates 29–31), *The Last Supper* (plates 44–47) in Santa Maria della Grazie, *Lady with an Ermine* (plates 27 and 28), and possibly the fresco decoration in the Salle delle Asse of the

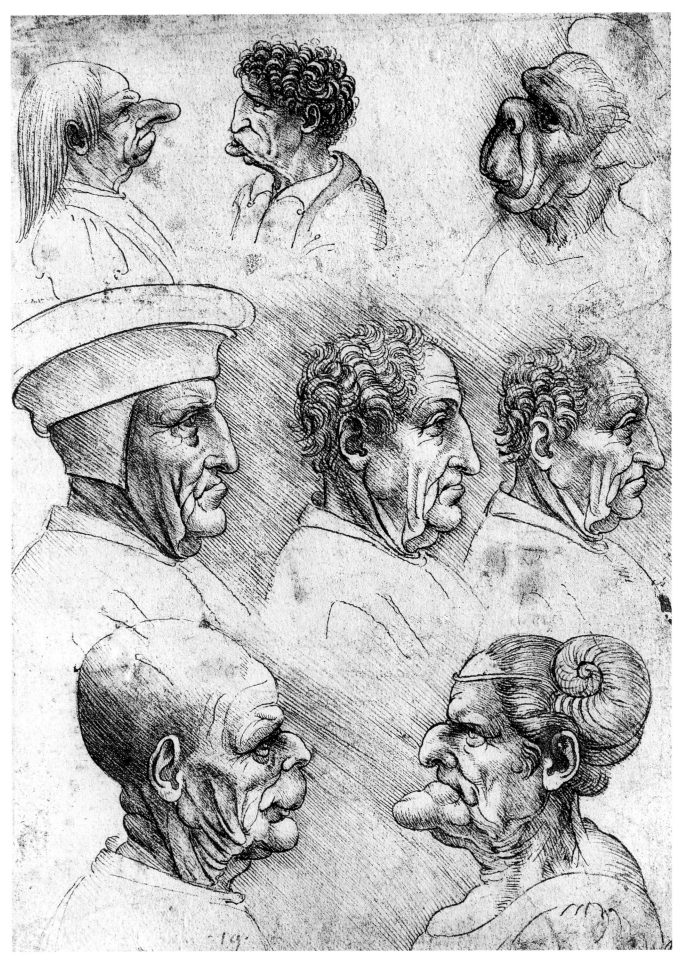

PLATE 36 opposite
Eight caricatures (study)
Silverpoint touched with white on cream paper,
7¹/₈ x 6¹/₄ inches (18.1 x 15.9cm)

PLATE 37 right
Six grotesques
Drawing

*Leonardo made many drawings of grotesque heads, depicting with
great psychological insight the wide range of human types with
which we are all familiar and overstating the characteristically
revealing features to a point which would now be called caricature.
In caricature, the identifying elements are repeated to the extent
that there is ludicrous exaggeration. For Leonardo the purpose
was different in that the distortions and exaggerations were not to
identify types but to pursue a deep analysis of individual spirit in
each different image.*

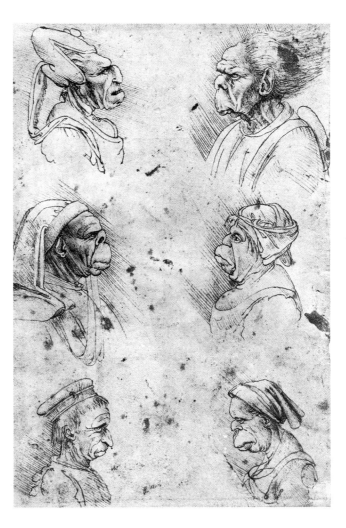

Sforza castle. Evidence of other work is now only to be
found in the drawings and reports of contemporaries
which have survived. Nevertheless, these constitute a wide
range of projected and executed work which indicate that
Leonardo was kept much occupied by Ludovico. His
many unexecuted architectural projects include studies for
different types of churches with centralized domes (plates
23, 25 and 26). Architecture was something that Leonardo
had offered in his now famous petition to Ludovico,
claiming: 'In time of peace I believe that I can give perfect
satisfaction, and to the equal of any other, in architecture,
in the design of buildings public and private, and in
guiding water from one place to another.' However, his
main architectural activity in Milan was advisory rather
than practical. In fact Leonardo, despite his deep interest
in architecture and having made many designs and plans
for architectural projects, never left any buildings even
started. Despite this, his architectural designs are of
sufficient importance for him to be included in any
examination of the architecture of the period.

For Ludovico's frequent courtly festivities, Leonardo
produced many designs for decorations, theatricals,
tournaments, costumes and decorated vehicles, including
'parade weapons' which show his inventive genius, as well
as wall decorations for specific occasions. An example of
these last are to be found in the Salle delle Asse mentioned
above. They were seriously damaged by incompetent

restoration early in this century but later, more sensitive,
work has partially restored their effect. Drawings for his
parade weapons include an ingenious scythe mechanism
designed to cut the legs off the horses of advancing
mounted troops, and the first known design for a wheeled
armoured tank. (See plates 10 and 11.)

Some observations on Leonardo's scientific work are
perhaps appropriate at this point. Leonardo saw himself
primarily as an artist and all his activities are approached
from this standpoint. Where art and science first came into
direct contact for him was in his *Treatise on Painting*;
although this work is now seen only in a compilation
made under the supervision of his student and heir,
Francesco Melzi. The intended form of this important
publication, a landmark in the study of the technical and
aesthetic elements of the art process, was indicated by
Leonardo through notes and recorded conversations, and
indicates the breadth of his concerns in this area. The
Treatise was intended to examine perspective (linear,
colour, aerial), light and shade, colour theory, human form
(proportion and anatomy) and its motion (physical and

spiritual), composition, representation of man and representation of nature, including cosmic forces (atmosphere, clouds, water, air, wind) and the structure of the earth and plant life. The notes for the treatise stretched over many years, from about 1490 to at least 1513, the major part of Leonardo's career in Italy. Leonardo believed that he must not only express the laws of nature in terms of feeling (abstract) but in a concrete form (practical application).

In addition to an examination of the artistic disciplines, Leonardo was committed to explaining (in encyclopedic terms) the whole range of human knowledge, extended by him where appropriate. This encyclopedia would include optics, mechanics as the study of organic and inorganic forces, biology as the study of growth and life, and cosmology as the nature of active energy in the universe. Leonardo believed that as an artist he was equipped to undertake this enormous all-

encompassing task since the artist had the dual capacity of perceiving and transmitting ideas. In many ways, the whole of his life was devoted to the realization of this and his writings, drawings and even his paintings are part of his preparation for a project never to be completed. His enquiries into the subjects listed above reveal the range of his intellect and although they cannot, for obvious reasons, all be further pursued here must of necessity form part of the background to the examination of his paintings and other art projects.

Of course, any attempt to arrive at a consistent systematic philosophy from all that has been left of Leonardo's work would neither be possible nor profitable. He is neither adding to (comparable with the philosophy of, for instance, the early Greeks) nor is he merely (an apparently derogatory but in his case descriptive term) gathering notes and information, not searching for a rational and highly elaborated philosophy.

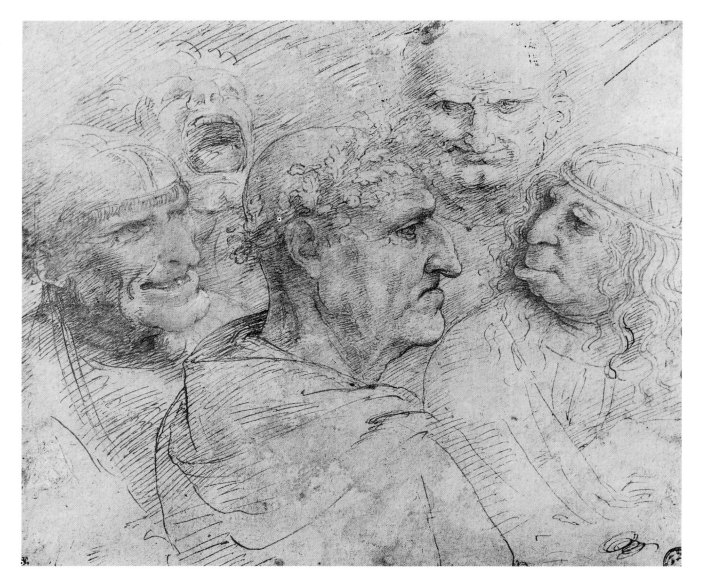

PLATE 40
The Canon of Vitruvius (c. 1492)
Drawing in pen and ink with text, 13¹/₂ x 9⁵/₈ inches (34.3 x 24.5cm)

This study of the proportions of the human body is related to both a square and circle. The centre of the square is at the genitals and that of the circle at the navel, while the outstretched arms provide a square with the height and the spread legs and arms meeting the circumference of the circle. It is a somewhat artificial structuring but it provides a canon of proportion which has been related to the Vitruvian model from the writings of the first century B.C. Roman architect.

PLATE 41
Study of a hand
Drawing

PLATE 42 page 54
Female anatomical study
Drawing and text

PLATE 43 page 55
Anatomical study of the muscles of the neck and shoulders
Drawing and text, 11¹/₂ x 3⁷/₈ inches (29.2 x 9.8cm)

The small selection of anatomical studies here and on the following pages indicate Leonardo's interest (one of many) in the human form of which he made numerous drawings. In some instances these were preparatory studies for a painting, i.e. the hand illustrated below, or were made following his dissection of human bodies (usually executed criminals) such as the female form on page 54. Together these drawings represent an extraordinary journey of discovery.

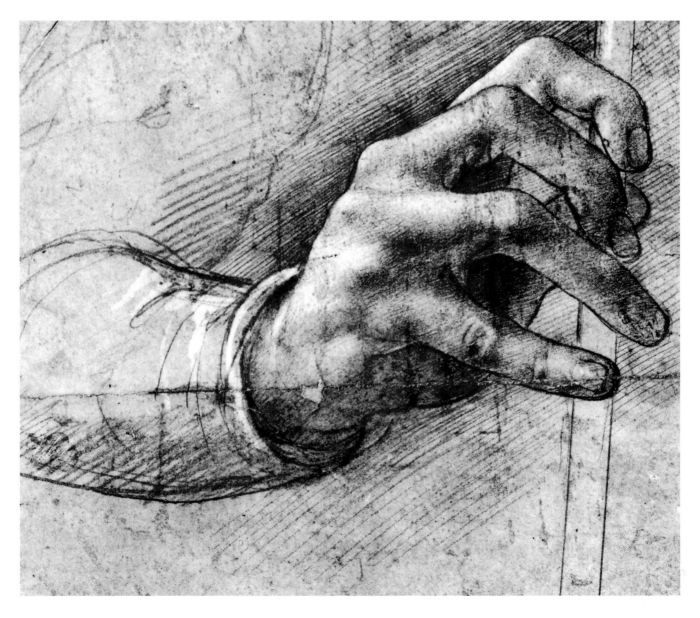

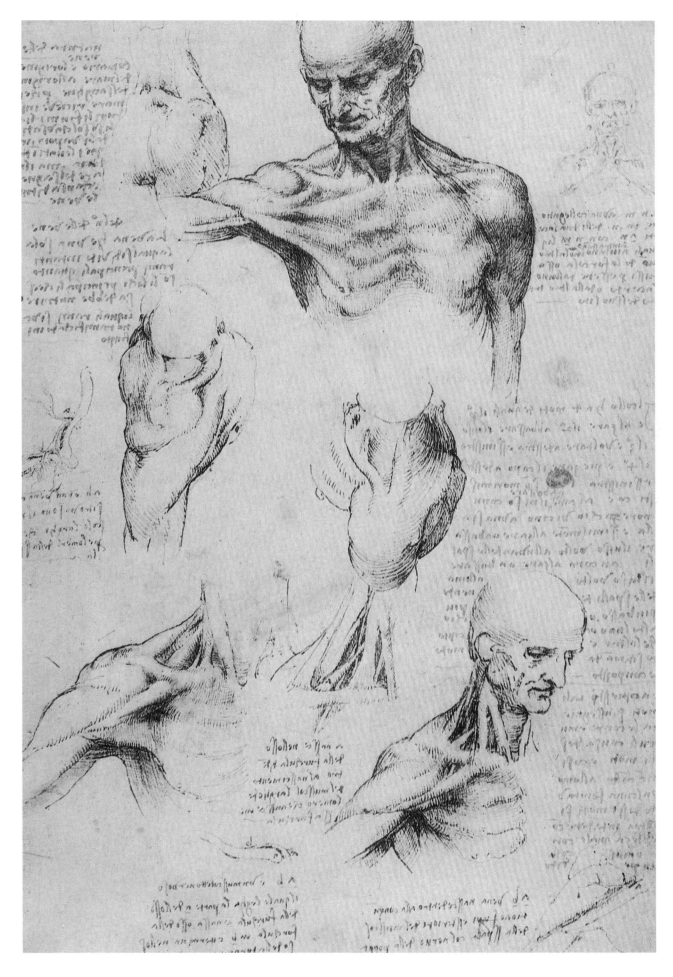

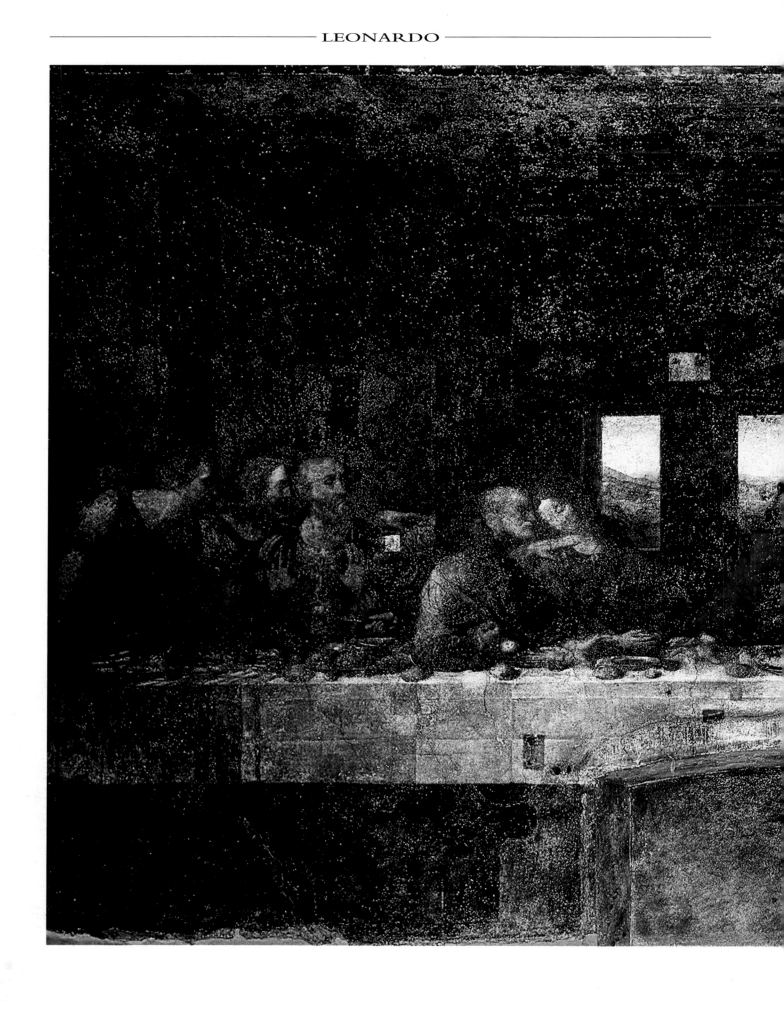

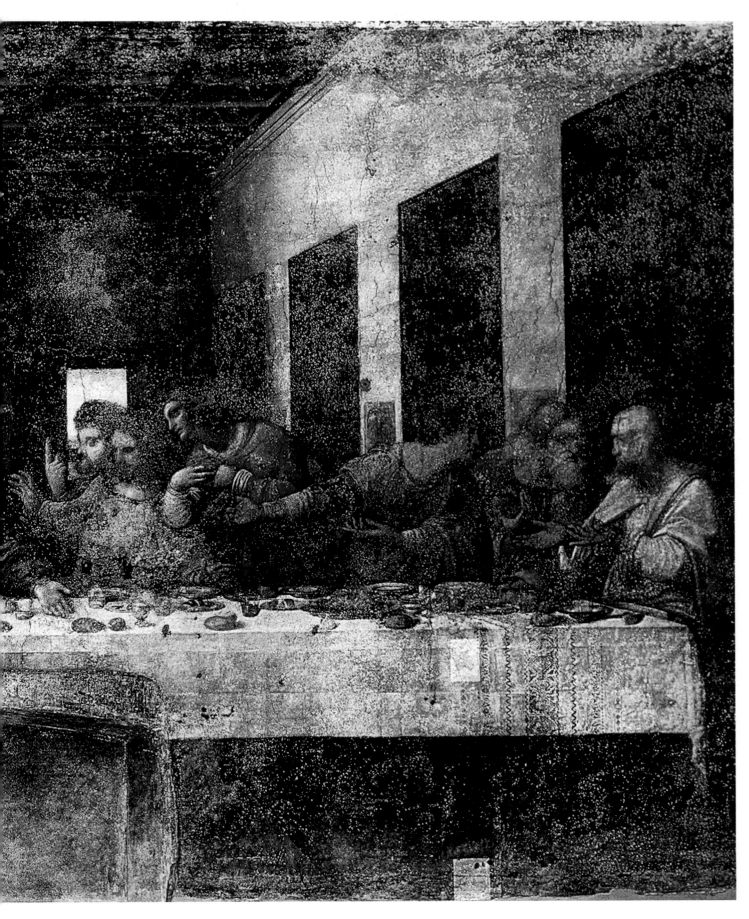

PLATE 44 previous pages
The Last Supper (1495–97)
Fresco, 15 x 29ft (460 x 880cm)

The extremely poor condition of this painting on the end wall of the refectory of the church of Santa Maria delle Grazie is notorious and despite every effort to maintain it the deterioration seems likely to continue. In any event, we are no longer looking at a work by Leonardo but a repainted image to a design and composition by him. It is nevertheless an imposing sight and the drama of the composition and colour scheme is discernible. The central figure of Christ is surrounded by the two groups of three disciples on either side of him while two other groups of three are at the end of the long, cloth-covered table. All the figures are dramatically engaged within their own group with the exception of Judas whose hand stretches towards the purse, the strong shadow down his front emphasizing his hand. The picture plane is broken by a clear perspective, its depth being opposed by the cloth running across the length of the painting. It is a simple construction, beautifully controlled and containing animated figures which are a reminder of the importance that Leonardo attached to the significance of every gesture and movement of the human form. A report of an onlooker present while Leonardo was working is a fascinating insight: 'He would often come to the convent at early dawn; and this I have myself seen him do. Hastily mounting the scaffolding, he worked diligently until approaching darkness compelled him to stop, never thinking of food at all, so concentrated on his work was he. On other occasions he would stay there for three or four days without touching the painting, only coming in for a few hours to remain in front of it, with folded arms... '

The reason for the decay is technical. Leonardo's temperament was not in sympathy with fresco, the appropriate method for murals on the surface confronting him. It is demanding in the extreme, requiring an orderly procedure of preparation quite at variance with Leonardo's wish for a free and spontaneous approach. Oil was his preferred method and his adoption of a mixed method on the wall meant that it would not adhere even in the short term and with humidity this was shortened further.

PLATE 45 top right
The Last Supper (detail of disciples)

PLATE 46 right
The Last Supper (detail of disciples)

PLATE 47 opposite
The Last Supper (detail of Christ)

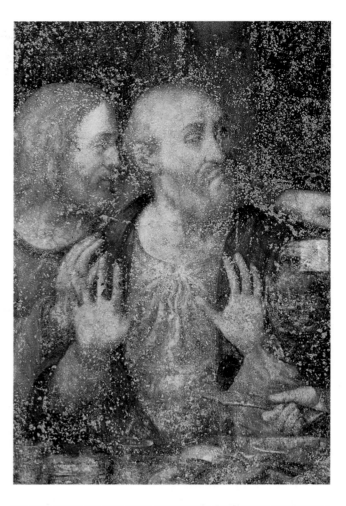

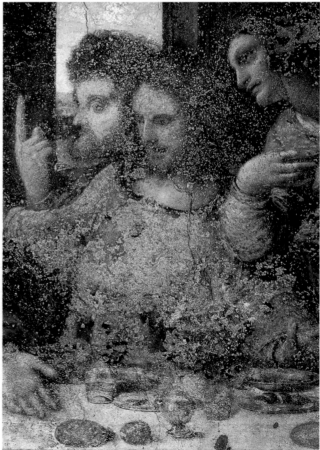

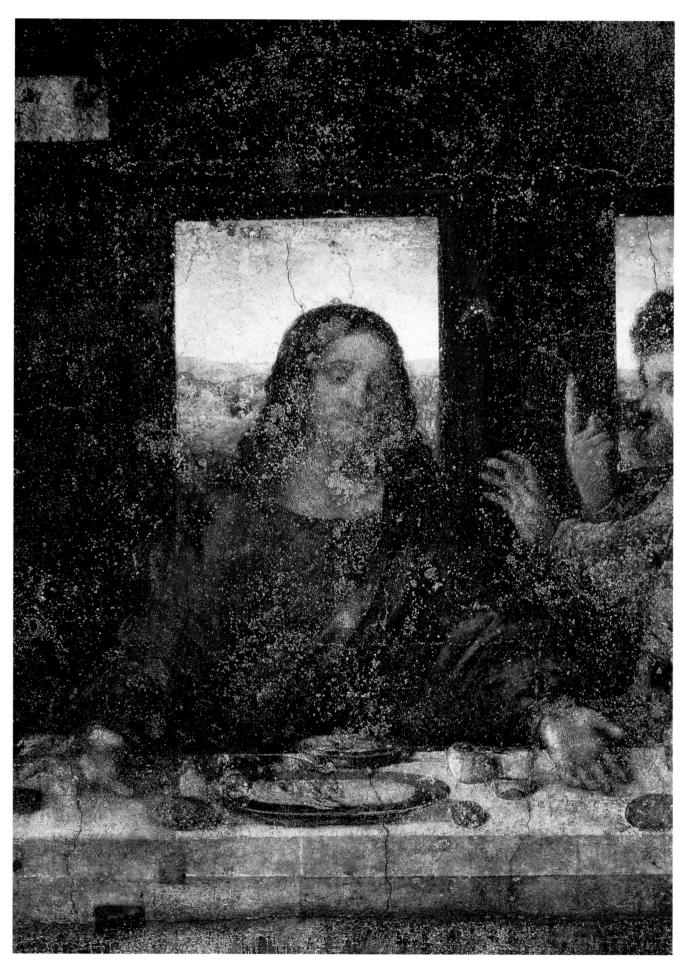

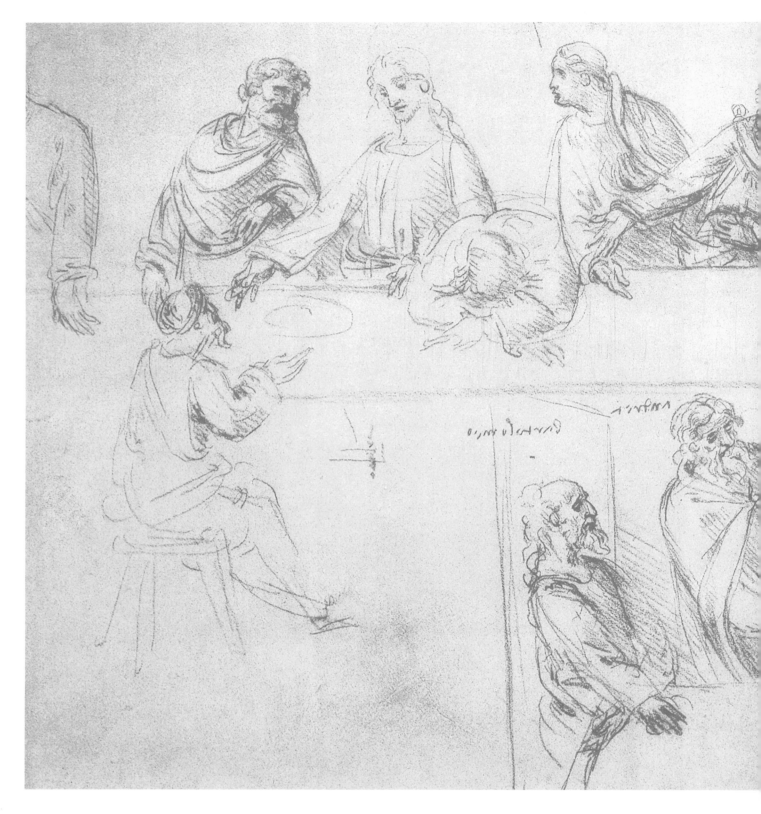

continued from page 51

he began to organize his plans for his encyclopedia.

At this time Leonardo was at the height of his powers, admired by Raphael and even, if grudgingly, by Michelangelo. In 1506 he was invited by the king of France to return to Milan where he remained until 1513 in the court of Charles d'Ambroise, the French governor of Milan. For him, he undertook a number of architectural designs including one for a large residential palace. He also produced plans for the chapel of Santa Maria alla Fontana. Other works, including another equestrian sculpture like the Sforza monument, were never realized. Perhaps his scientific work is of the greatest interest at this time in which his astounding geological

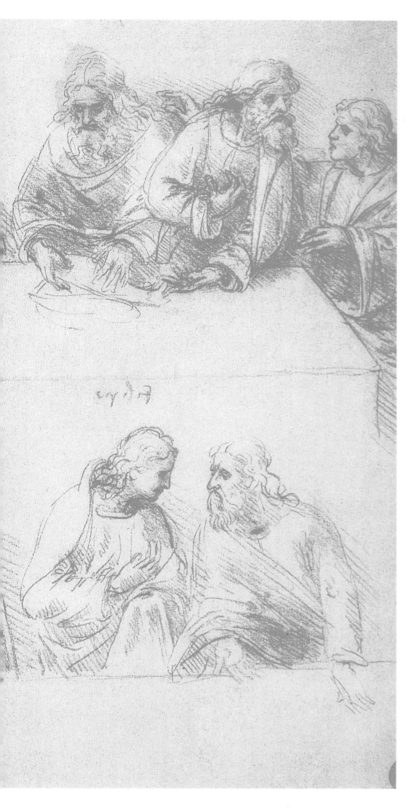

PLATE 48
Studies for The Last Supper (1497)
Sanguine, 10¼ x 15⅜ inches (26 x 39.1cm)

For this important commission, the largest he completed, Leonardo made numerous sketches and studies and it is evident from these that he paid great attention to the pose of each figure in order to indicate their different characters. It is this controlled authority of composition that distinguishes this great but damaged work.

PLATE 49 below
Portrait of Isabella d'Este (1500)
Pastel, sanguine and pierre noire, 24¾ x 18⅛ inches (63 x 46 cm)

Isabella d'Este (1474–1539), one of the great ladies of the Renaissance, was the sister of Ludovico Sforza (Il Moro), a patron of Leonardo who called him to Milan. She was married to Francesco Gonzaga, Duke of Mantua, the mother of eight children and a great patron of the arts. According to a contemporary letter to Isabella, Leonardo agreed to paint several panels for her as well as her portrait, but it is uncertain whether he ever attempted to honour any such commitment. No full portrait exists but this study was made before Leonardo left Milan. The drawing shows her to be a sharp-faced young woman, full of self-confidence. It is generally accepted that this is a work by Leonardo.

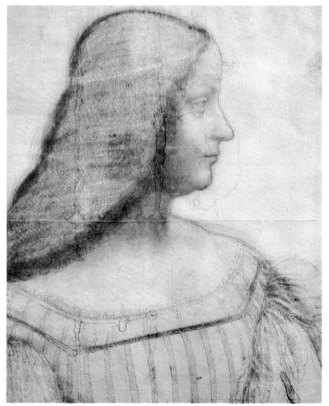

study of fossils led him to consider the early extent to which water covered the earth. His precise drawings of botanical specimens, establishing him as the founder of modern scientific illustration, are of equal significance.

When Giovanni de' Medici, second son of Lorenzo the Magificent became Pope Leo X in 1513, Leonardo went to Rome in the expectation that on the return to

PLATES 50 (detail below) and 51 opposite
The Mona Lisa (La Gioconda), 1503–07)
Oil on panel, 30¼ x 20⅞ inches (77 x 53cm)

Even the Mona Lisa is not free from dispute or doubt. What is clear is that the painting was in the French Royal Collection at Fontainebleau in 1625 and remained there until 1805 when it entered the Louvre, in Paris. It is believed that Francis I purchased it for 4,000 francs and it is known that he provided Leonardo with the Château Cloux, near Amboise.

It was the practice of the wealthy patrons of artists to have their portraits and those of their wives painted. These portraits were usually in a domestic setting, often in profile, with indications of the sitters' special interests or qualities. The identification of the subject of this painting as the young third wife of the Florentine merchant Francesco di Bartolommeo del Giocondo was first made by Giorgio Vasari, a generation after it was painted. Another report claims that it was painted at the request of Giuliano de' Medici, Leonardo's patron in Rome. The qualities of this portrait have been extolled by many writers, despite the layers of varnish and accumulated dust which disguise the delicacy and subtlety of the modelling. It is not cleaned for fear of damaging it further and yet it remains one of the most potent images of womanhood in all art. The incipient smile, the sense of absolute peace enveloped in an atmosphere of immutability, establishes the work's pre-eminence in portraiture.

Of all the literary quotations that might be offered, that of Walter Pater in his book The Renaissance *is perhaps the most evocative and inspiring, and worth repeating here. 'La Gioconda is, in the truest sense, Leonardo's masterpiece, the revealing instance of his mode of thought and work... We all know the face and hands of the figure, set in its marble chair, in that circle of fantastic rocks, as in some faint light under sea. As often happens with works in which invention seems to reach its limit, there is an element in it given to, not invented by the master... The presence that rose thus so strangely beside the waters is expressive of what in the ways of a thousand years men had come to desire. Her's is the head upon which all "the ends of the world are come", and the eyelids are a little weary. It is a beauty wrought out from within upon the flesh, the deposit, little cell by cell, of strange thoughts and fantastic reveries and exquisite passions.' Pater does not mention that amid the fantastic rocks there is a vestigial sign of human presence in the winding road on the left and the bridge on the right.*

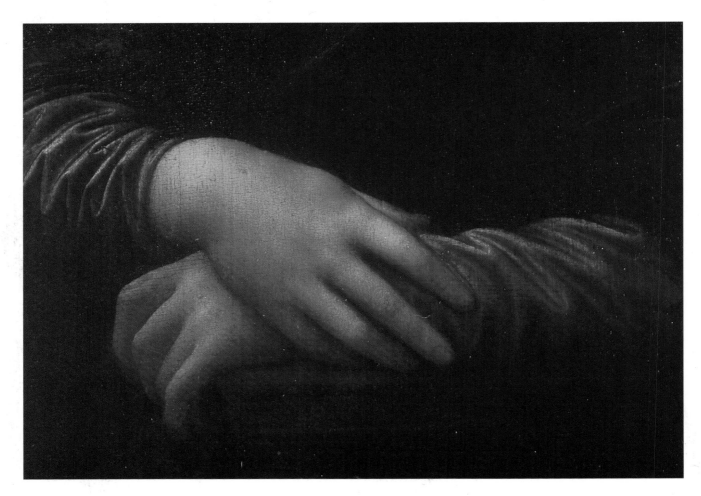

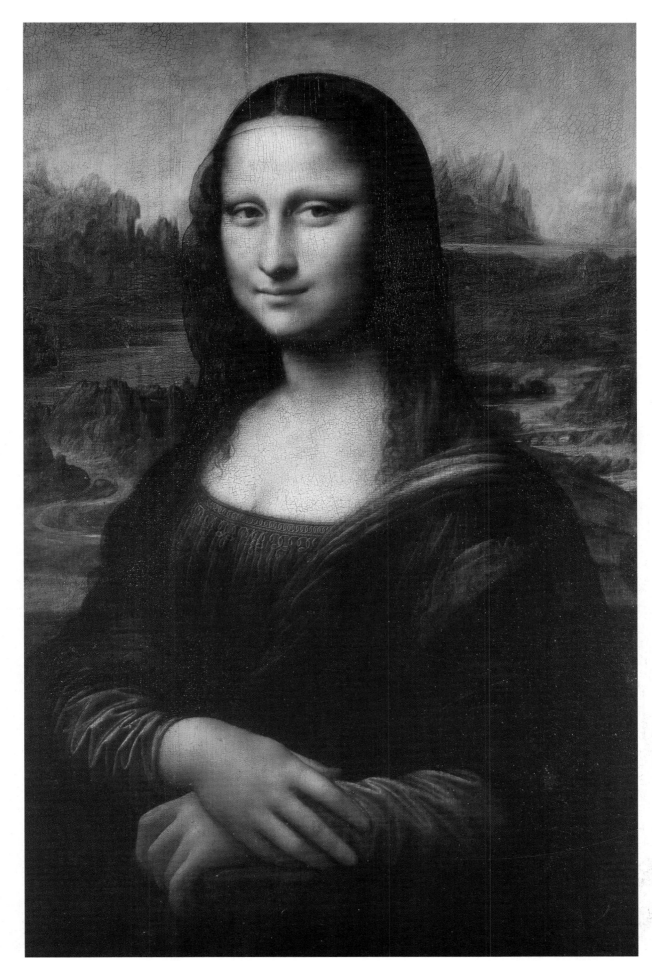

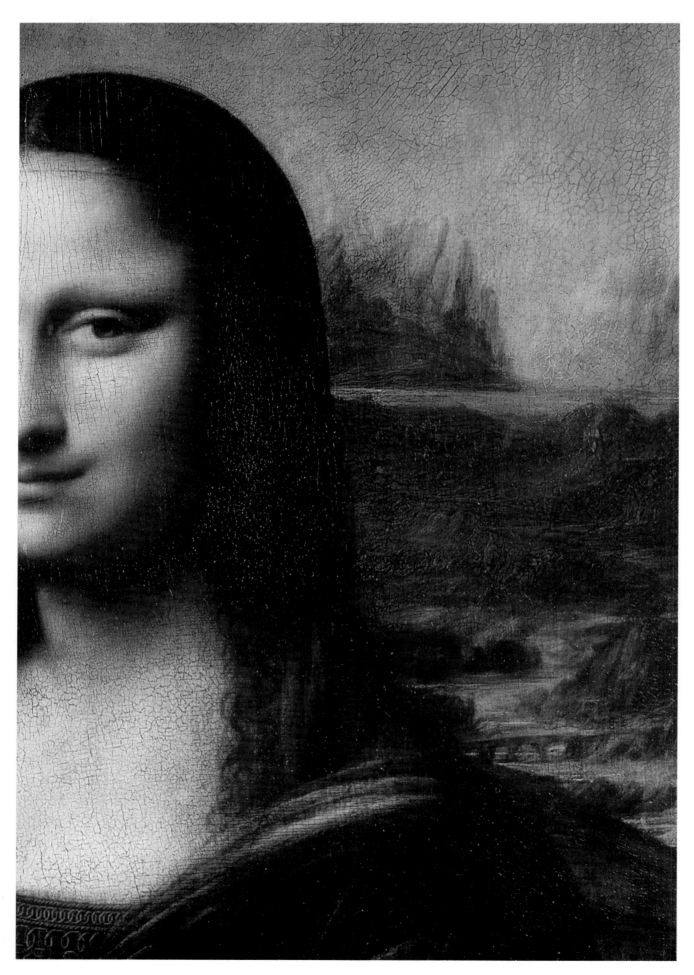

PLATES 52 (detail opposite) and 53 detail right
The Mona Lisa (La Gioconda)

This small oil painting, visited by thousands in the Louvre Gallery, Paris, is perhaps the most famous icon in the world and for many who see it this is somewhat baffling. Why should this painting have been singled out for such acclaim and mystic status when there are literally hundreds of similar paintings of similar subjects belonging to the same period which are of equivalent technical quality and draughtsmanship? It is difficult to offer any convincing or definitive reason, but it is probably a combination of many factors, not the least the wish to find some image that could represent the superhumanity of a man who, though recognized as such, left so much that was unfinished or damaged that this simple but subtle image with its undefined mystery set in an unearthly landscape seems the only work to encapsulate his very spirit.

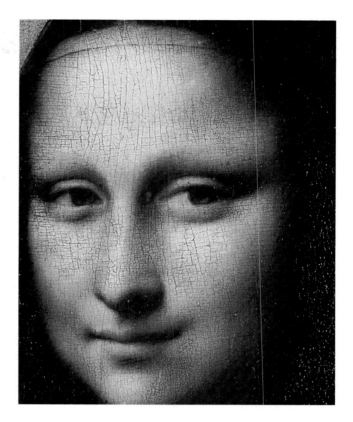

power of the Medici he would receive work from his patron, Cardinal Giuliano de' Medici. His great contemporaries, Bramante, Raphael and Michelangelo had been offered important commissions but nothing of similar importance was offered to Leonardo. While in Rome, Leonardo continued his scientific enquiries, especially in the realm of anatomy, and there is only one painting, *St. John the Baptist* (plates 62 and 63), which dates from this period that may be attributed to him. If it is by Leonardo, it is his last known work; but more than a little scepticism still exists.

In 1517 Leonardo made his last move. He left Rome for France at the invitation of Francis I, king of France who granted him the title of *Premier Peintre, Architecte, et Méchanicien du Roi*. He was given the Château Cloux, near Amboise where he died on 2 May 1519. Francis I had also bought Leonardo's *Mona Lisa* for 4,000 francs, which accounts for its present location in the Louvre as one of its most admired works. No paintings executed in France have remained but Leonardo had continued his scientific studies, particularly in anatomy, which had been an important concern of his for some years. The only project of his last years in France that is clearly documented is for a large castle and gardens for the Queen Mother. The castle was not built, but the plan is in some ways reflected in the castle of Chambord built in the lifetime of Francis I. The drawings and notes of Leonardo's last years include

the dramatic *Deluge* series, a most impressive example of his lifetime dedication to the study of natural phenomena.

Leonardo was interred at Amboise in the church of St.-Florentin, but his tomb and remains vanished in the destruction of the church during the French Revolution in 1789. His unique corpus is his only physical monument but represents a small part of the intellectual legacy of one of the greatest minds and most fascinating and challenging figures in the history of mankind. He is the one figure who remains an unchallengeable example of the whole being greater than its tangible parts.

LEONARDO'S ARTISTIC ACHIEVEMENT

Something further must be said of Leonardo's position in the history of Western art. He is always considered, along with Michelangelo and Raphael, as being at the pinnacle of Renaissance artistic creativity. But compared with them, his actual physical legacy is small and ultimately not comparable in actual achievement. He saw himself primarily as an artist but when given other forms of commission was happy to describe himself as, for example, an engineer. The universality of his genius is such that painting, had it been even more central to his life and had he left a larger *oeuvre*, would still have remained a fraction of his life's work. Indeed, it is likely that the sublime, almost mystical reputation of his *Mona Lisa* has grown only because there is not much else upon which to pin

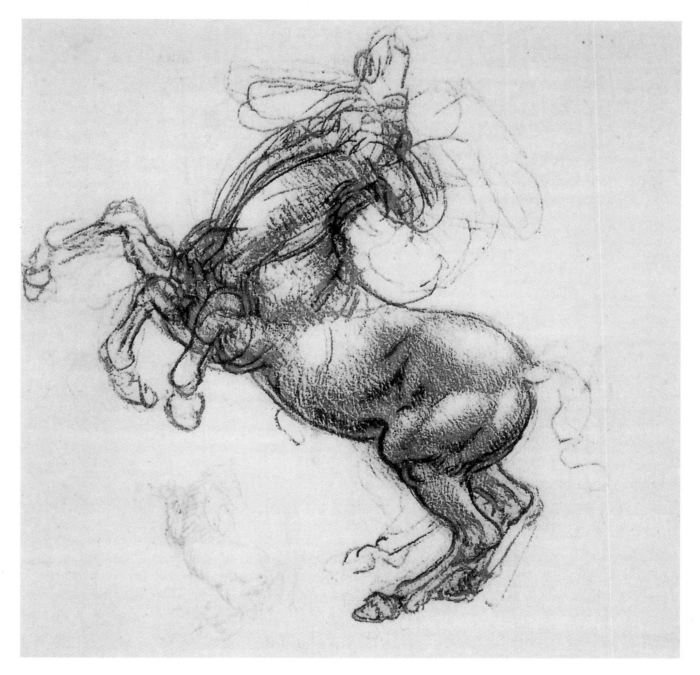

PLATE 54 opposite
Study for the Sforza equestrian monument
(c.1490–91)
Silverpoint, 8½ x 6¼ inches (21.6 x 16cm)

It seems likely that Leonardo started on the design for the Sforza monument soon after the end of the great plague of Milan in 1485. After working on a rearing horse design and being deflected by the logistics of constructing such a large-scale bronze, he returned to the traditional treatment of the horse which is seen in this plate. A clay model of great size was produced (known as the colosso) measuring about 23ft (7m) from hoof to mane and about twice the size of comparable works such as Donatello's Gattamelata in Padua. The size is most likely the stipulation of

the Sforzas when they commissioned the work in commemoration of the founder of their dynasty, the condottiere Francesco, rather than Leonardo's own wishes.

PLATE 55 above
Rearing horse
Sanguine, 6 x 5⅝ inches (15.3 x 14.2cm)

This is related to either The Adoration of the Magi or is a preparatory study for The Battle of Anghiari. (See plates 9 and 14–16.) There is also a possibility that it was a study for the planned Trivulzio equestrian statue since Leonardo intended a rearing horse for this work which was never realized.

such an enormous artistic reputation, and because the painting was early located in Paris, the great centre of European art and, in 1805, in the Louvre galleries. It is also partly because the existence of any evidence is precious that all the works Leonardo has left are given iconic status. But only partly, because within the small corpus there is an encapsulation of the spirit of the Renaissance and the emergence of a new realization of the nature and potential of man that is present nowhere else, not even in the creative passion and so-called *terribilità* of Michelangelo nor in Raphael's elegant purity. Leonardo has not only produced a few images of the spirit of rational man at its most penetrating but is himself the iconic form of its entire breadth. We contemplate him in terms that leave a sense of longing; would that there could have been more.

Even so, the images – partly because they are so few – have qualities that focus the sensibilities. The *Mona Lisa*, La Gioconda, the wife of a Florentine merchant transported to the palace of a French king, has acquired in the public perception a different identity, a spirituality, a

tranquillity, remoteness and contained force that aspires almost to divinity. There are many fine portraits of Renaissance women but somehow, so far inexplicable, this is different – an entire expression of womankind. That this uniqueness of identity can be applied to other works by Leonardo is also true. His *Virgin of the Rocks*, Louvre, Paris, for instance, is a quintessential altarpiece of Christian belief. It is not that he advanced the technique or draughtsmanship of painting in the way that he opened up vistas in other disciplines or indeed what he initiated in them, it is that the purity of his vision and the depth of his sensitivity are such that his technical abilities are entirely in tune. The subtle chiaroscuro that he achieves in oil painting is not at that time achieved by others and this gives his work an atmosphere, a space that carries many implications. On his return to Florence after his period of service to the Sforzas in Milan, Leonardo had developed an approach to the effect of light and colour which he introduced into the artistic life of Florence. The effect of chiaroscuro was added to by what has come to be known as *sfumato* and is particularly associated with Leonardo.

PLATE 56 opposite

Text and sketches on the subject of bird-flight

Pen and ink

See caption to plates 21 and 22 on page 32

PLATE 57

Studies of cats and dragons

Pen and ink and wash over black chalk

An endearing and curious page from one of Leonardo's notebooks, which includes careful and fanciful drawings of cats in characteristic attitudes accompanied by a few dragon-like creatures with slightly feline features. One can imagine this page having been drawn to amuse a child.

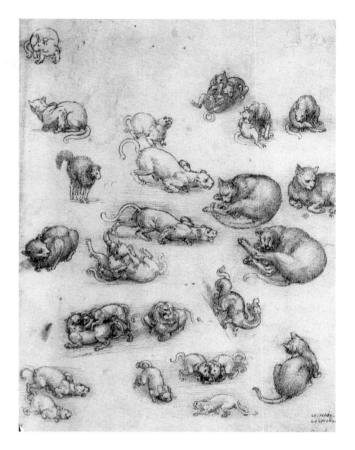

Changes from light to shadow were delicately blurred, giving a subtle sense of the actual atmosphere surrounding objects. It was an important contrast to the defined draughtsmanship of Michelangelo and most Florentine painters and pointed the way to the later years of the 16th century and onwards to the next.

A major problem when considering Leonardo's paintings is the difficult task of attribution and the extent to which they can be considered as wholly by him or in part. And there is a particular problem with one of his most famous works commissioned by the Duke of Milan, *The Last Supper* (plates 44–47), in the Refectory of the church of Santa Maria delle Grazie, Bramante's church in Milan. It is perhaps no surprise, when one considers Leonardo's intellectual curiosity, that the technique of painting interested him and, depite the major commission and the large scale of this work he was not deterred from experimentation with materials and surfaces. The painting is in an oil tempera mixture, executed on a wall. Inherent in the method was its progressive deterioration and throughout the centuries it has been necessary to undertake restoration which now is almost continuous. It is not surprising that little of the original work remains. When painted, it was probably a work of intensity and luminosity and not the wreck it now appears to be. Even 50 years after it was completed, Vasari described it as a

'muddle of blots'. How then to evaluate such a painting when what we see is not what the artist painted? The painting is obviously a great tourist attraction to the city and the church, to add a certain cynicism to the assessment, and obliteration is therefore not to be contemplated.

Much of Leonardo's artistic intention can be discovered from the study of the drawings he made daily for most of his life. They are of various subjects on a single sheet; sketches of figure poses, caricatures, semi-technical drawings, architectural designs, anatomical studies, some botanical, and all controlled by a keenly analytical mind. They are wonderfully intriguing, there are a great many of them, and it is through them that much of Leonardo's genius may be enjoyed. The single best assemblage of these is to be found at Windsor Castle and forms a central part of Her Majesty's unique collection.

Although Leonardo made designs for sculpture and architecture, some of them highly finished, there are no examples of either sculpture or buildings to examine. It is consequently necessary to incorporate his drawings to a greater extent than is usual in any study of an artist, and they form a larger part of the illustration than is usual in an art book. However, most of the paintings generally attributable to him are included, with details where helpful. It should be remembered that only 17, four of them unfinished, are considered possible.

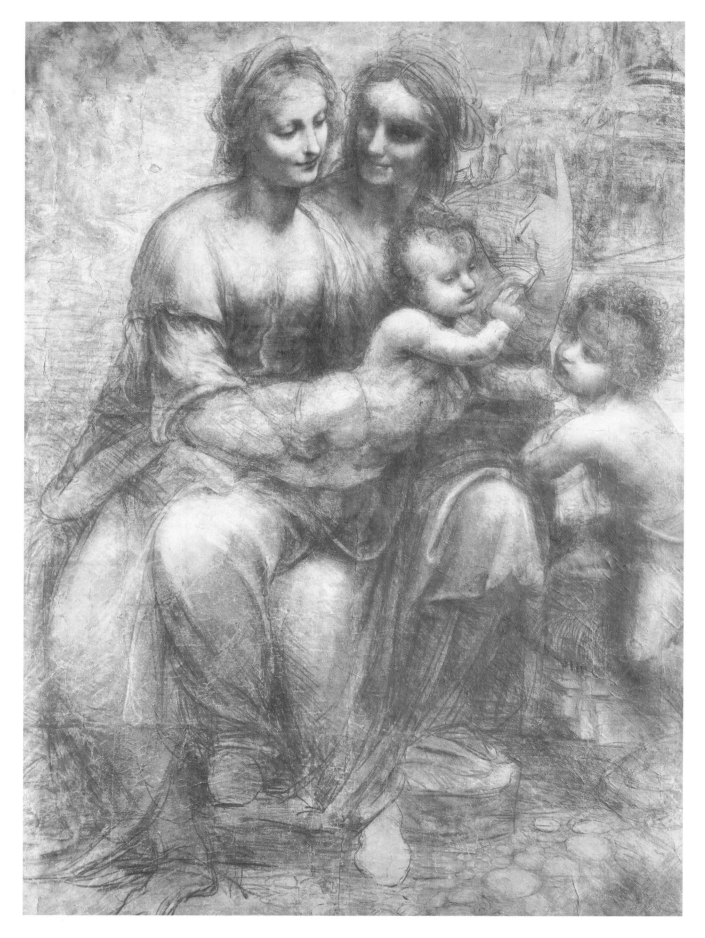

PLATES 58 (opposite) and 59 detail below

Virgin and Child with St. Anne and St. John the Baptist (c.1500)

Black chalk heightened with white on brown paper, 55³/₄ x 41¹/₆ inches (141.5 x 104.6cm)

Generally accepted as a work by Leonardo but not chosen for a painting, this cartoon is one of at least three of the same subject and the dating of them is open to conjecture. The National Gallery catalogue suggests the mid 1490s, others the early 1500s. It has also been suggested that it may have been the work commissioned by Louis XII in October 1499 when Louis was in Milan at the head of his conquering army. Like much of Leonardo's work, its provenance is uncertain but the quality of the work, the brilliant modelling of the head of St. Anne and the assured structuring of the group makes its attribution almost certain. One of the interesting aspects of the work is Leonardo's treatment of the spatial relationship between the Virgin and St. Anne who seem almost to meld, to be two aspects of a single figure. The pointed finger, characteristic of Leonardo and almost overused at times, would be an identifying sign were it not for the number of other painters who adopted it from him. The contrast between the candid fresh face of the Madonna concentrated on the welfare of the children and the somewhat mysterious, quizzical look and firm line of the mouth of St. Anne seems to suggest that she is fearful of the virgin's future anguish. There is an almost mystical aura surrounding the two heads.

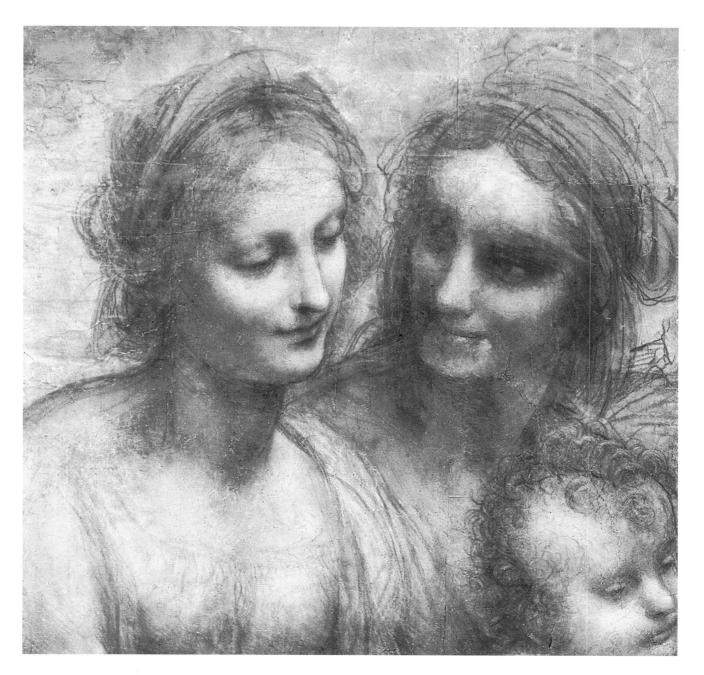

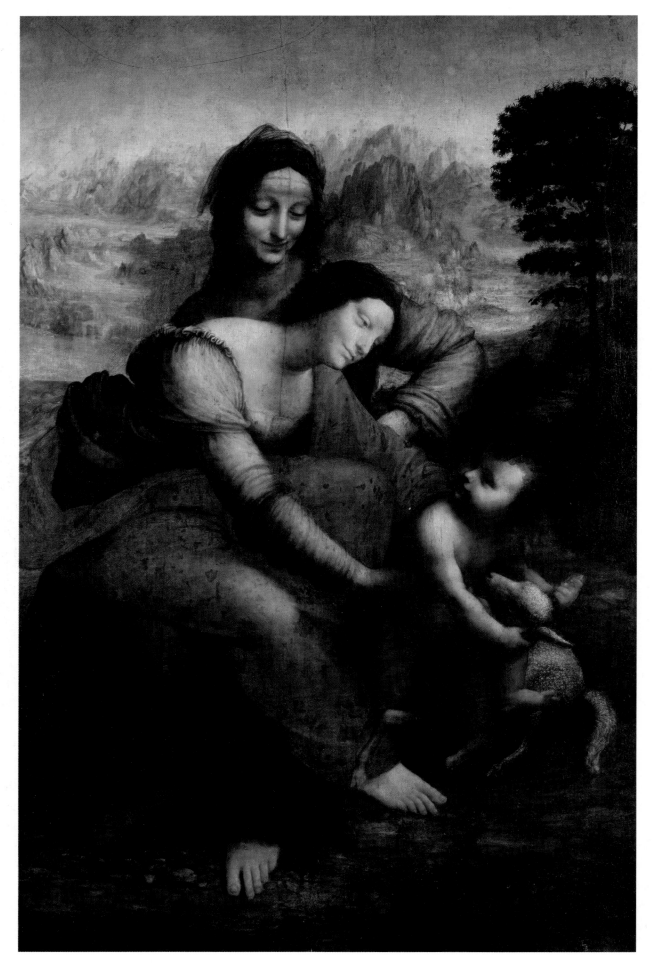

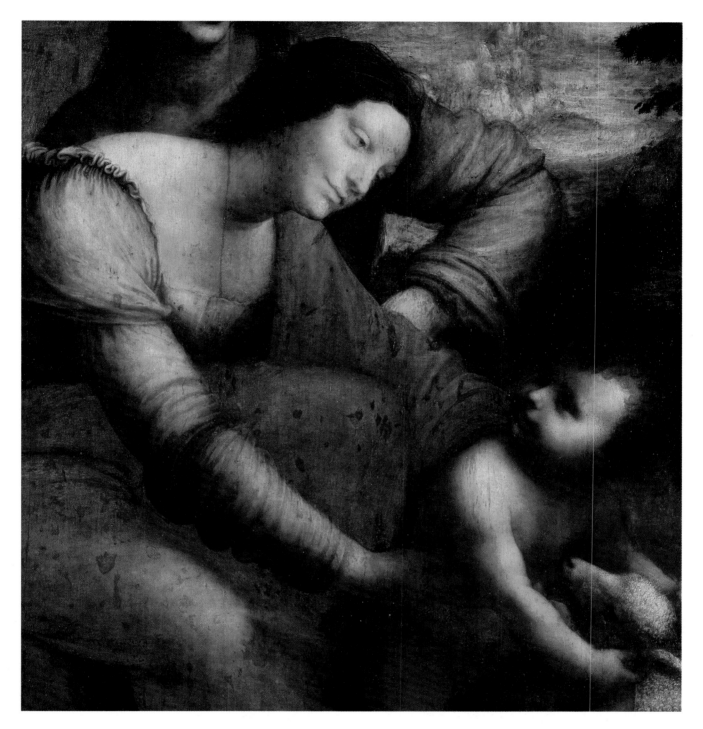

PLATES 60 (opposite) and 61 detail above
Virgin and Child with St. Anne (c. 1508–10),
Louvre, Paris
Oil on panel, 66¹⁄₈ x 51¹⁄₆ inches (168 x 130cm)

*The earlier version of the subject (plates 58 and 59) includes St.
John the Baptist while here he is replaced with the Lamb. The
charcoal drawing is the earliest version of a subject Leonardo
returned to a number of times. The Louvre painting is unfinished
and is the fourth and last interpretation of the theme. In this,
according to a Carmelite monk, Fra Pietro da Novellara, the*

*Virgin is trying to keep the Christ Child away from the Lamb
'which signifies the Passion', while her mother, St. Anne,
discourages the Virgin from interfering in Christ's destiny. In this
painting the Virgin is perched more securely on her mother's knee
although, yet again, there is an unnatural spatial unity between
the two figures. St. Anne seems a more detached observer than in
the previous cartoon. The landscape is treated with a light delicacy
which belies the moonlit unreality of its craggy forms. One is
reminded of the otherworldliness of Christ's mission, 'Behold the
Lamb of God which taketh away the sins of the world'.*

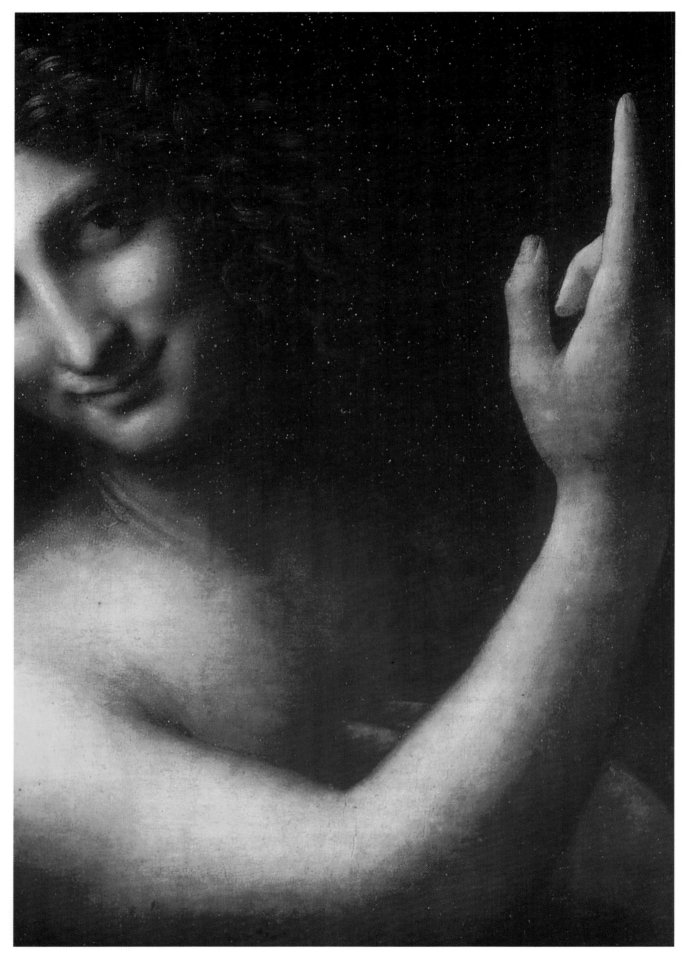

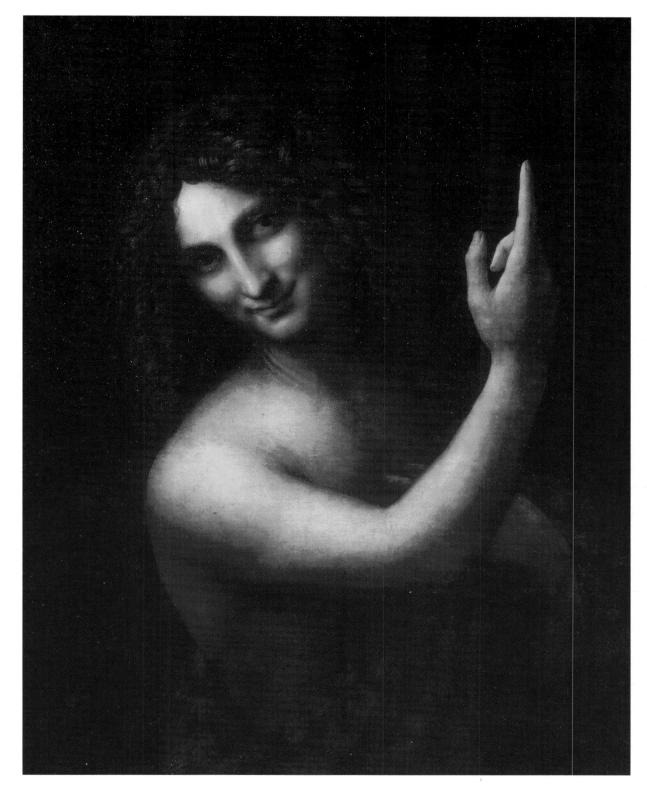

PLATES 62 (detail opposite) and 63 above
St. John the Baptist (c. 1513–16)
Oil on panel, 27¹/₈ x 22³/₈ inches (69 x 57cm)

Unlike La Belle Ferronnière *(plates 34 and 35), it is agreed by most critics that this is the work of Leonardo and that although innovative in a number of ways is singularly unattractive, almost repellent. The modelling is flaccid, the anatomy strangely unconvincing and one might almost wish it were not by Leonardo. It seems almost a pastiche of his style with the enigmatic smile and the too often used erect digit. It is nevertheless an original treatment of the subject, a form in isolation with a certain internal energy emerging from the darkness. It is a presage of the powerful chiaroscuro of Caravaggio nearly a century later.*

ACKNOWLEDGEMENT

The Publishers wish to thank the following for providing photographs, and for permission to reproduce copyright material. While every effort has been made to trace and acknowledge copyright-holders, we wish to apologize should any omissions have been made.

Self-Portrait
Palazzo Reale, Turin/Alinari/Giraudon, Paris

Verrocchio: The Baptism of Christ
Uffizi Gallery, Florence/Alinari/Giraudon, Paris

Study of Drapery
Uffizi Gallery, Florence/Alinari/Giraudon, Paris

Study for Virgin and Child with a Cat
Musée Bonnat, Bayonne/Lauros/Giraudon, Paris

Study for The Adoration of the Shepherds
Bonnat Collection, Paris/Giraudon, Paris

The Annunciation
Uffizi Gallery, Florence/Alinari/Giraudon, Paris

Study of landscape (Val d'Arno)
Uffizi Gallery, Florence/Alinari/Giraudon, Paris

Two studies for The Battle of Anghiari
Galleria dell'Accademia, Venice/Alinari/Giraudon, Paris

War equipment
Bibliothèque des Beaux-Arts/Giraudon, Paris

War equipment
British Museum, London/Giraudon, Paris

Head of a warrior
British Museum, London/Bridgeman/Giraudon, Paris

Study of a hanged man
Musée Bonnat, Bayonne/Giraudon, Paris

The Adoration of the Magi
Uffizi Gallery, Florence/Alinari/Giraudon, Paris

Preliminary sketch for The Adoration of the Magi
Louvre, Paris/Giraudon, Paris

Study of architecture with figures for The Adoration of the Magi
Uffizi Gallery, Florence/Alinari/Giraudon, Paris

Giant catapult
Biblioteca Ambrosina, Milan/Bridgeman/Giraudon, Paris

Sketch for an aerial screw (ancestor of the helicopter)
Bibliothèque Mazarine/Giraudon, Paris

Study for flying-machine
Bibliothèque d'Institut de France/Giraudon, Paris

Study for flying-machine
Bibliothèque d'Institut de France/Giraudon, Paris

Designs and plans for a church
Bibliothèque d'Institut de France/Giraudon, Paris

Building constructions
Bibliothèque d'Institut de France/Giraudon, Paris

Architectural drawing for church (such as that of San Sepulcro in Milan)
Bibliothèque d'Institut de France/Giraudon, Paris

Plans and elevations of churches
Bibliothèque d'Institut de France/Giraudon, Paris

Lady with an Ermine
Czartoryski Museum, Cracow

The Virgin of the Rocks
Louvre, Paris/Giraudon, Paris

Study of an angel's head for The Virgin of the Rocks
Palazzo Reale, Turin/Alinari/Anderson-Giraudon, Paris

Head of an old beardless man, turned to the left
Musée Bonnat, Bayonne/Giraudon, Paris

La Belle Ferronnière
Louvre, Paris/Giraudon, Paris

Eight caricatures (study)
Windsor Castle/Alinari/Anderson-Giraudon, Paris

Six grotesques
Louvre, Paris/Valardi/Giraudon, Paris

Five male heads
Louvre, Paris/Giraudon, Paris

Two heads: an old man and a youth
Uffizi Gallery, Florence/Alinari/Giraudon, Paris

The Canon of Vitruvius
Galleria dell'Accademia, Venice/Alinari/Giraudon, Paris

Study of a hand
Pinacoteca Ambrosiana/Alinari/Anderson-Giraudon, Paris

Female anatomical study
Windsor Castle, Royal Library/Alinari/Anderson-Giraudon, Paris

Anatomical study of the muscles of the neck and shoulders
Windsor Castle, Royal Library

The Last Supper
Church of Santa Maria Delle Grazie/Alinari/Giraudon, Paris

Studies for The Last Supper
Galleria dell'Accademia, Venice/Alinari/Giraudon, Paris

Portrait of Isabella d'Este
Louvre, Paris/Giraudon, Paris

The Mona Lisa (La Gioconda)
Louvre, Paris/Giraudon, Paris

Study for the Sforza equestrian monument
Windsor Castle, Royal Library

Rearing horse
Windsor Castle, Royal Library

Text and sketches on the subject of bird-flight
Bibliothèque Mazarine/Giraudon, Paris

Studies of cats and dragons
British Museum, London

Virgin and Child with St. Anne and St. John the Baptist
National Gallery, London/Giraudon, Paris

Virgin and Child with St. Anne
Louvre, Paris/Giraudon, Paris

St. John the Baptist
Louvre, Paris/Giraudon, Paris